The World of Edward Gorey

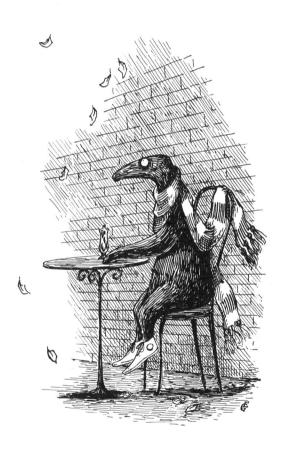

The World of

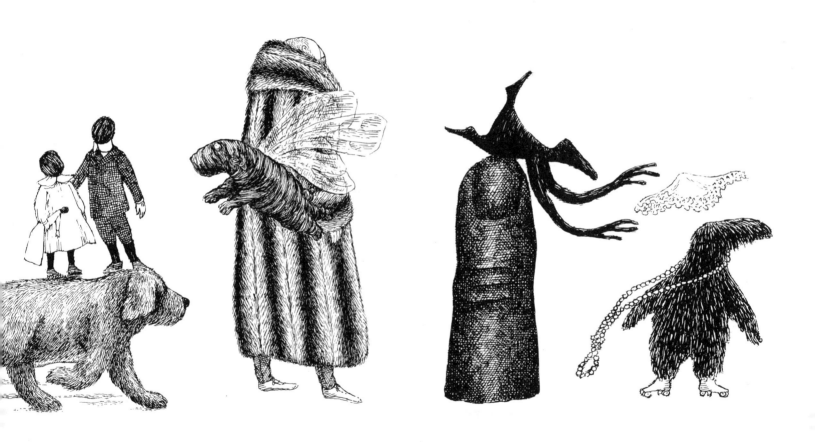

Edward Gorey

by **Clifford Ross** and **Karen Wilkin**

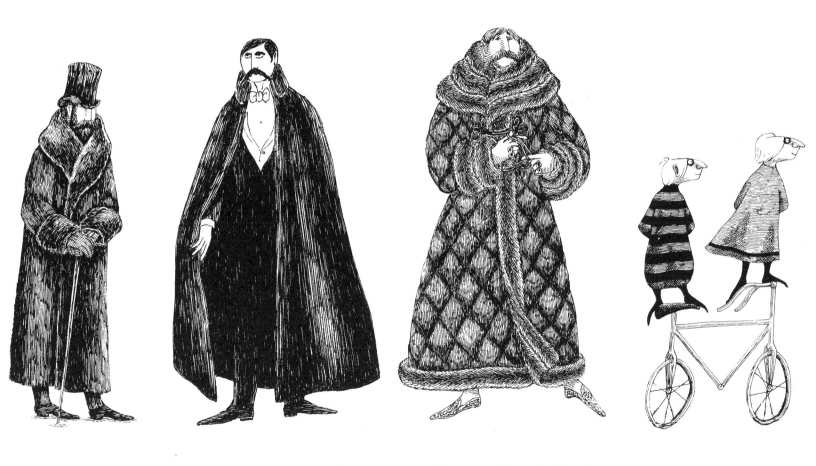

Harry N. Abrams, Inc., Publishers

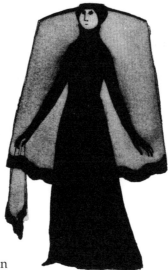

Editor: Ruth A. Peltason Designer: Judith Michael

Page 1: Drawing for "The Doubtful Guest" from *Leaves from a Mislaid Album*. Pages 2–3, from left to right: From *The Very Fine Clock*; from *The Prune People*; *Self-Portrait with Flying Dog*; from *The Raging Tide*; from *Les Urnes Utiles*; from *Dracula, a Toy Theater*; from *Les Echanges Malandreux*; from *The Epiplectic Bicycle*. Pages 4, 5, and 7: Drawings for the animated title sequence of *Mystery!* television series. Page 6: Front cover design for *The Gashlycrumb Tinies or, After the Outing*

The Library of Congress has cataloged the clothbound edition as follows:
Ross, Clifford, 1952–
The world of Edward Gorey / by Clifford Ross and Karen Wilkin.
p. cm.
Includes bibliographical references.
ISBN 0–8109–3988–6 (clothbound)
1. Gorey, Edward, 1925– —Criticism and interpretation.
I. Wilkin, Karen. II. Title.
NX512.G67R67 1996
700'.92—dc20 95–47900
ISBN 0–8109–9083–0 (paperback)

Paperback edition published in 2002 by Harry N. Abrams, Incorporated, New York
Clothbound edition published in 1996 by Harry N. Abrams, Inc.

Printed and bound in Hong Kong
10 9 8 7 6 5 4 3 2 1

Harry N. Abrams
100 Fifth Avenue
New York, N. Y. 10011
www.abramsbooks.com

Abrams is a subsidiary of

LA MARTINIÈRE
G R O U P E

Contents

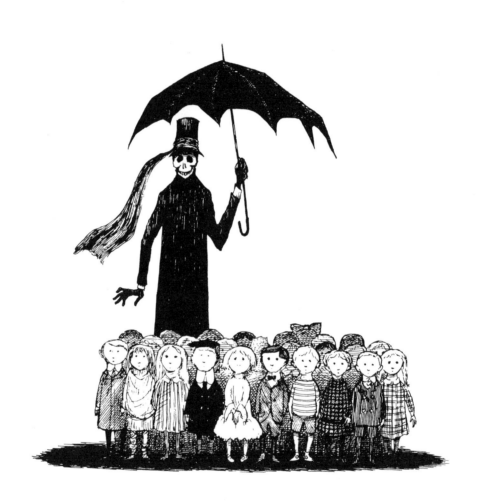

Acknowledgments

Thanks to Ruth Peltason, our editor, Judith Michael, our designer,
to Andreas Brown and the staff of the Gotham Book Mart for their invaluable help,
and particularly to Edward Gorey.

—C. R. and K. W.

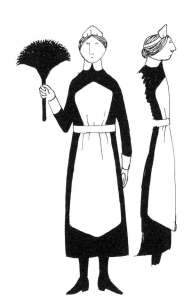

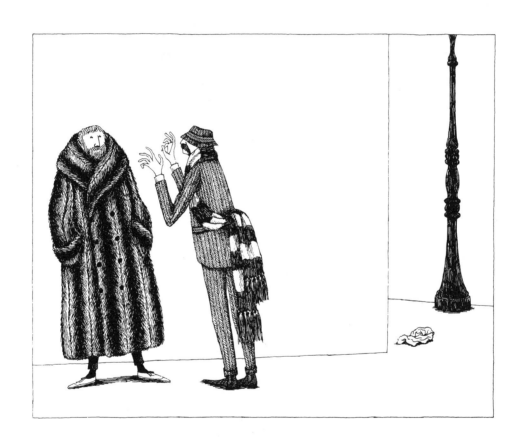

Interview with Edward Gorey

by Clifford Ross

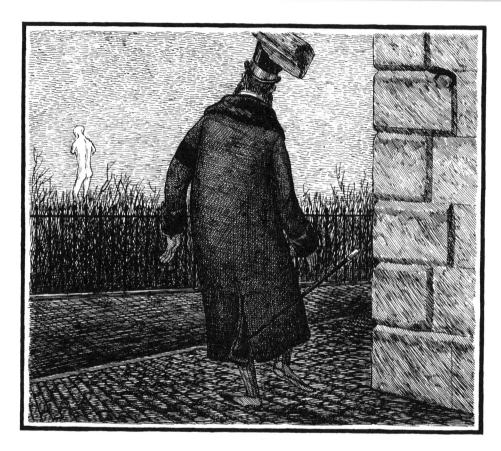

Her only other relative, an uncle, was brained by
a piece of masonry.

his interview was conducted over a two-day visit to Edward Gorey's Victorian home on Cape Cod in August 1994. A poison ivy vine had made its way through a window casing in the living room.

Clifford Ross: Does nature inspire you at all?

Edward Gorey: I've never really attempted to create any form from nature. I often think, "Oh, wouldn't this vista make a lovely landscape drawing." But I wouldn't dream of attempting it.

CR: Well if not nature, then what?

EG: I'm always taken with the sports photographs in *The New York Times,* which are not the sort of thing that anybody has ever really painted. I suppose the nearest thing to them are Bacon's use of still photographs from Eisenstein's *Potemkin.* Bacon's one of those people where I'm always thinking, "Oh, we've all been taken in." And then I go and see a Bacon show and I swoon all over again. But for a while there I did think he'd finally gotten so he was just doing the same kind of scumbled portrait over and over. You know, some of his paintings are ravishingly beautiful, even the most absolutely horrifying ones. I mean they're almost too beautiful, some of them. But no matter how horrifying anything is, or how interesting, sooner or later it's just so much wallpaper on the wall.

CR: What about other artists, like Constable or Cézanne?

EG: I'm perfectly willing to admit that Cézanne is a great, great painter. But don't ask me exactly why. And anybody who followed him is a lot of hogwash.

CR: You wouldn't include Matisse in that, would you? I thought he was one of your big favorites.

EG: Well, he is. But Cézanne . . . I've probably seen I-don't-know-how-many exhibitions of his watercolors. You know, great expanses of watercolor paper with a little yellow blob here, in front of a little yellow blob there. And I think, "Oh, I know we're all supposed to swoon away before all the spaces with the raw paper showing through." And Picasso I detest more than I can tell you. I long since ceased looking at Picasso You know, I'd like to think that it was Manet who really wrecked painting forever.

Opposite: From *The Hapless Child.* 1961

CR: You don't want to credit Goya?

EG: No, I don't. I know what you mean, but Goya is still painting. I can remember when that big Manet show turned up at the Met. My friends and I came to the first picture. I can't remember whether it was a man or a woman standing in front of a horse, which was facing to the left. And we said, "That horse's leg is in front of the leg of the man standing in front of the horse." And someone said, "There's an awful lot of that in this show." And it was true. And a picture of some harbor or something. Pasted against it are black silhouettes of boats. It's ludicrous. It's just a terrible painting.

CR: And yet you love and collect Albert York's work.

EG: Because Albert York knows how to paint. Manet, well, it's just as if everything had deliquesced or is on the way to deliquescing.

CR: Does Surrealism interest you?

EG: The whole theory of it comes closer to my philosophy than almost anything.

CR: What wing of it? Are you talking about Delvaux and Magritte? Or Max Ernst? Or André Masson?

EG: Max Ernst. Collage, frottage, and bricolage. Some of his paintings are quite wonderful. I probably would never have done Figbash if he hadn't done Loplop. I more or less grew up with *Two Children Are Threatened by a Nightingale* at The Museum of Modern Art.

CR: If Manhattan were going to sink . . .

EG: What would I save?

CR: You get three paintings from permanent collections.

EG: Probably the Georges de la Tour in the Frick collection, just because I'm so mad about it. You know, the Virgin with the little Jesus wrapped in swaddling clothes and the little girl holding the candle behind her hand. And well, even if it's not in Manhattan, the one Goya painting that I would save, because it haunts me more than any other, is *The Dog Half Submerged*. And, of course, a Vermeer

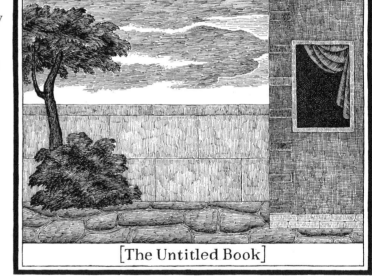

[The Untitled Book]

Above and opposite: Covers for *The Untitled Book*. 1971

12

CR: You'd take a Vermeer

EG: And if I could have any Matisse, it would be *The Red Studio.* Of course I never believe Matisse when he says, "Now don't do these slapdash things that I do because I've spent years doing this and only I can do it with authority." I'm not saying that most of his paintings aren't perfectly wonderful, but I'm not at all sure that somebody else couldn't do just as well. In a way I feel he's the most mysterious of all painters. I mean he makes Goya look fairly simpleminded. With Goya you know where you are, strange as it all is. You know, I might have to abandon Vermeer for a Piero Della Francesca—*The Flagellation of Christ.* Or, on the other hand, the Uccello where everybody's headed into a black wood with little spindly trees. I don't think your list is large enough, somehow. I tend to go for the things that are rather frozen in time. It occurs to

by Edward Pig

me that I am really more concerned with sculpture than painting. Maybe if I could have anything of Matisse's I would take that sculpture of a three-legged horse. He made an edition of about six, so I suppose there's hope somebody will give one to me someday. "Mr. Gorey, I read you wanted that horse. I have an extra." It's funny because you could offer me a Bernini or a Canova, and I'd say, "Oh, take it away, please!"

CR: What do you think of abstract painting? Are you moved by it?

EG: It's part of what I said about Surrealism. I love the theory of Surrealism, but when push comes to shove there's very little Surrealist art that I would care to own. Or read. I'm always trying to read Surrealist novels. Of course my own work is Surrealist. Well, people feel it is Surrealist. And it is in a way. It's not so much that I'm not interested in Surrealist art, as I just feel the theory goes bouncing way ahead of anything that's produced.

CR: The aspects of your work that most people comment on are its weird, threatening, or macabre qualities. But I also think of your work as being very funny.

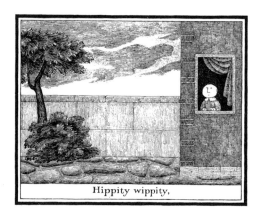

Hippity wippity,

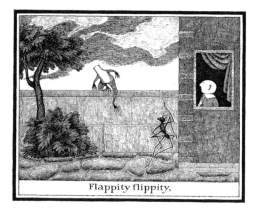

Flappity flippity,

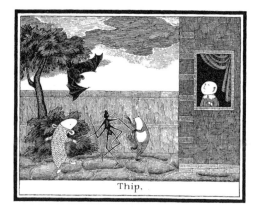

Thip,

EG: Well, I don't think I've done anything terribly scary. People think of me as much more macabre and Gothic than I really am. And the macabre and Gothic don't really interest me very much any more. I don't think they ever did. That was just the way it came out.

CR: On my last visit you were showing me a book of photographs of small children who had died.

EG: That book I found very difficult to sit and look at straight through. But I do collect postcards of dead babies. Did I ever recommend to you that book of photographs that Luc Sante dug up when he was researching his book about the underworld in New York? They're

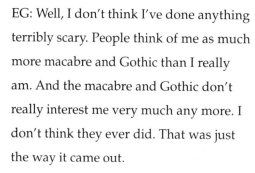

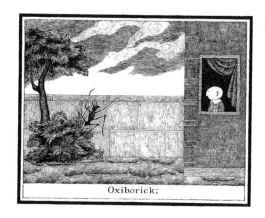

Oxiborick;

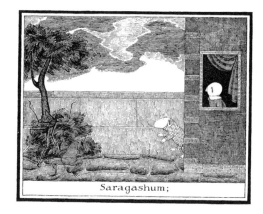

Saragashum;

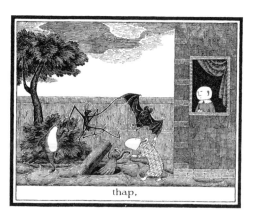

thap,

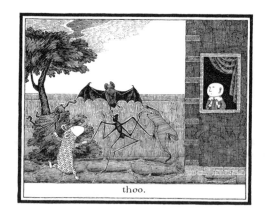

thoo.

Above and opposite: *The Untitled Book.* (Complete)

ravishingly beautiful crime scenes. Sometimes the corpse and everything. There's a completely fortuitous, Surrealist aspect to a lot of them. They were taken with a camera pointed to the floor on a tripod so that you can see the three feet of the tripod, and sometimes the feet of the photographer. And some completely

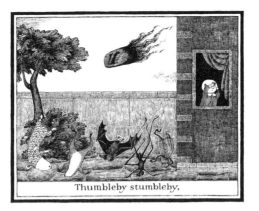

Thumbleby stumbleby,

inexplicable photographs of just a street at night. "Is this a blood stain in the foreground or isn't it?" They have the same haunting quality as Atget's photographs. By the way, I must say, I would cheerfully sell my soul to be able to draw like some people.

CR: Like whom?

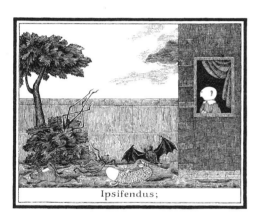

Ipsifendus;

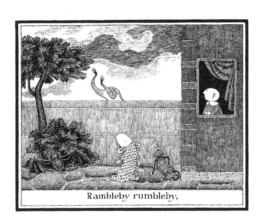

Rambleby rumbleby,

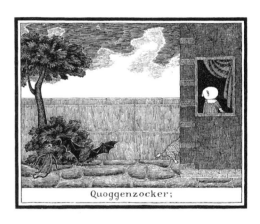

Quoggenzocker;

Hip,

hop,

hoo.

Pages 16–17: From *The Hapless Child*. 1961

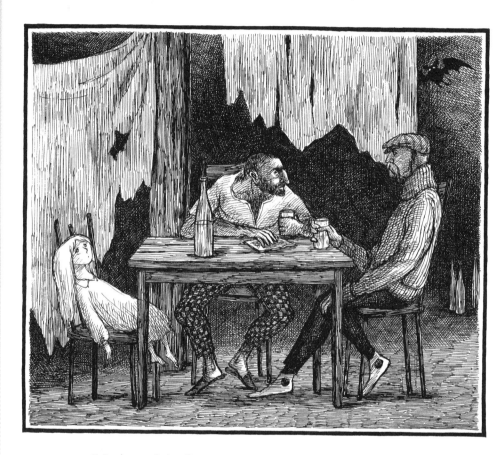

He sold her to a drunken brute.

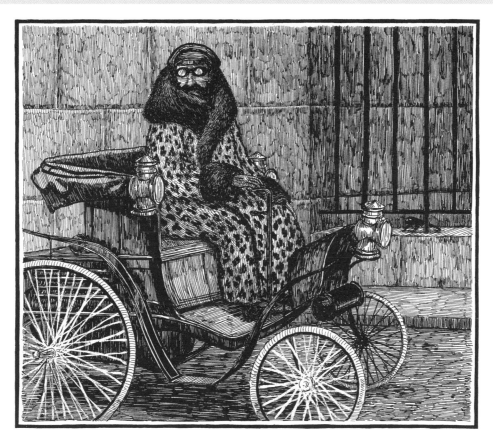

Every day he motored through the streets searching for her.

EG: Actually, the person I most wish I could draw like is someone you've probably never heard of named Edward Bawden, who's probably dead by now. He's an English artist who did both fine art and illustration. For instance, he used to do the catalogues for Fortnum and Mason, and he illustrated a two-volume edition of Herodotus. He does little black-and-white illustrations. He works in color sometimes, but mostly sort of black and white. He's got a black-and-white technique that I'd kill for. And Edward Ardizzone. He did a whole mass of children's books, which he wrote and illustrated. There again it's a very simple black-and-white technique. He illustrated things like *Pilgrim's Progress* and volumes of fairy tales. It's a very, very simple technique. But of course as he got older his technique got even sketchier than it was to begin with. It kind of fell apart a little when he was in his eighties. But he was entitled. And I would adore to be able to draw like Pisanello. Or Balthus for that matter.

The obvious choice in Balthus, for my taste, would probably be his illustrations for *Wuthering Heights*. As illustrations for *Wuthering Heights*, forget it. But they are just so compelling. I think if you go so completely over the edge, it is its own justification.

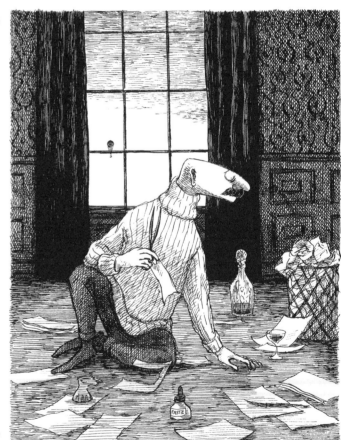

CR: What sort of art do you collect?

EG: Well, I have a couple of very minor Balthus drawings. I have three Burchfield drawings and one watercolor. I have five Albert York paintings and three pencil self-portraits. A couple of Vuillard drawings. I have a Bonnard drawing. And ten Atget photographs in tarnished brass frames. And I have one Munch lithograph, I think.

CR: Which one?

EG: *Omega and the Bear.* I couldn't resist it. It's this back of a naked lady and she's got her arms around a big bear. I think it has some significance. I'm not sure what. What else do I have?

From *The Unstrung Harp.* 1953. "Some weeks later."

I have one Klee etching. And a Berthe Morisot etching of a lady with a cat.

CR: What about the sandpaper pictures?

EG: Oh, I'm very fond of those. They are middle or late nineteenth century. They were something that ladies did. It's sandpaper with charcoal and chalk. They're usually grisaille, though I've seen color ones, which are sort of done in namby-pamby pastel colors. What they did was grind up marble dust and glue and spread it on paper.

CR: What about other objects you collect? Your house is filled to overflowing with all kinds of things.

EG: It's filled with little animals. Little things—

CR: Finials.

EG: Well, I do adore finials . . .

CR: An occasional piece of driftwood?

EG: Well, an occasional driftwood. I don't really come across that much. But finials. And I have lots of iron utensils. I buy those quite cheap at yard sales. I have trunks full of that stuff.

CR: What kind of utensils?

EG: I don't know, anything from pliers to large wrought iron things that hold the hinges on doors. And stuffed animals I've found occasionally at antique shows. And I would collect much more primitive art if I could afford it. There's a book that contrasts primitive stuff with twentieth century art. For instance, it will have an Amish quilt on one side and then have a . . .—Who paints squares?

CR: Albers.

EG: Somebody like that. It will have an Albers with a square or a rectangle, and it will have some metal object or sculpture. And in almost every case you think, "Why did anybody bother?" Because the primitive thing that was just made as a pair of pliers has so much more vitality. Some of those Amish quilts I think are just extraordinary.

CR: What about your working day?

EG: I usually wake up and think, "Oh, I really must do something today." But then quite often many things come up before I can start doing them.

CR: Do you work each day?

EG: I try and do something each day. Work might not be exactly the word for it.

CR: Having looked at your files, I've seen lists of words, notebooks with doodlings, phrases from stories never completed . . .

EG: Most of which disappear forever. Every now and then I will go through and think, "Oh, I really should do something more about that." And occasionally I may. I'm not sure about keeping notebooks, but you never know when you might want something. You might dry up completely. And then you have this little notebook that you can do something with. I used to think years ago, "Oh, God, suppose I never think of anything else? Suppose nothing else ever comes to me? You better write down everything." And I still do, because I never know when I might want to use it. Now I would rather not have any new ideas. Unfortunately, I have more than I ever did before.

CR: Do you find that you put some jottings or scribblings down in a notebook almost every day, even if you don't think of it as work?

EG: Yes, and I'm often putting my little notes in the margins of books for one reason or another.

CR: Do words, literary ideas, or images start the creative process?

EG: It just depends. It can be an image, or a quotation from somebody. Or something that actually happens, or that I see. I always tell people, "Be open to everything. Never close your mind because you never know where your next idea may come from." I've had too many ideas that have just come out of nowhere.

CR: So your sources can be as seemingly base as a cartoon on television?

EG: You just never know. I like the animated Batman that's on now. I really very much admire it. I kind of love the dark, simplistic quality of it. I'm not going to sit down and say, "I'm going to do something in the vein of Batman," but at the same time it's sort of in the back of my mind. You know, the Jungian idea that there's a personal subconscious and a collective subconscious. There are all sorts of things going on in our heads that may pop out at any time. It might be from your own subconscious or it might be from the collective subconscious. It might be some new take on an archetype, or

Opposite and above: Five sketches and notes for *The Secrets: Volume One, The Other Statue*. 1968. Pages 2, 3, 20, 21 from an undated notebook

from one's dreams. Unfortunately, I've never really been able to make use of my dreams, much as I would like to. Trying to reproduce them visually would be just too exhausting.

CR: Your books started out as much more reliant on words than on visuals. There has been an evolution, a consolidation, around the visual element. And the images have gotten more and more simple.

EG: I would like to get back to some fairly dense stuff some time.

CR: Let's get back to the steps you take in creating a book.

EG: I have to have the finished text before I draw. If I have a finished text, sometimes I will sit down and, within a month or two, do 14 drawings for a small book, or even 30 drawings, if they're not that complicated. With others, I may have written the text, 10 years will go by, and then I will start doing the drawings, get bored with them, put them aside, and I may not finish up the book for another 20 years.

CR: Is the text refined and polished before sketches are done of the illustrations?

EG: Oh, yes. Mostly I look to see that I haven't repeated the same word over and over again. If you've only got 30 sentences, you'd better have as much variety as possible.

CR: But those 30 sentences will exist before you even start sketching?

EG: Well, I may do a cover sketch or something. Sometimes I feel I'd better make a very bare-bones sketch. And sometimes I can't even read the bones they're so bare. The only reason for doing them would be to kind of make a storyboard that I could refer to later.

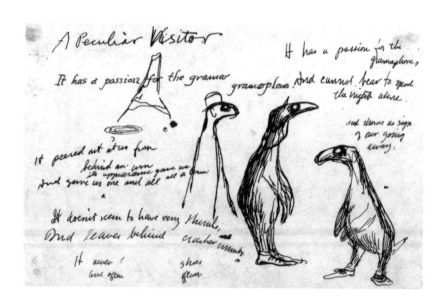

Sketches and notes for
"A Peculiar Visitor." c. 1955.
Published as *The Doubtful Guest*. 1957

Opposite, and pages 24–25:
From *The Doubtful Guest*. 1957

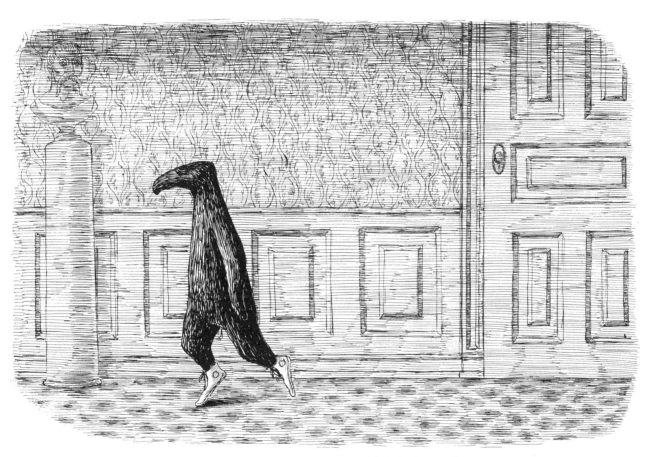

"In the night through the house it would aimlessly creep."

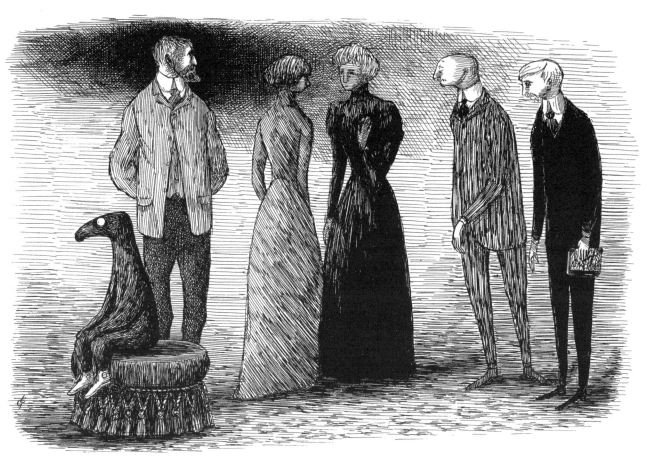

"It came seventeen years ago."

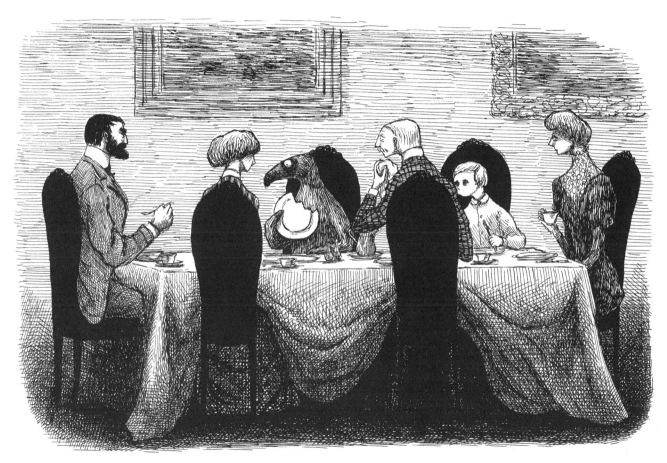

"It joined them at breakfast."

Prototype front and back covers for "The Visit." Published as *The Doubtful Guest*. 1957

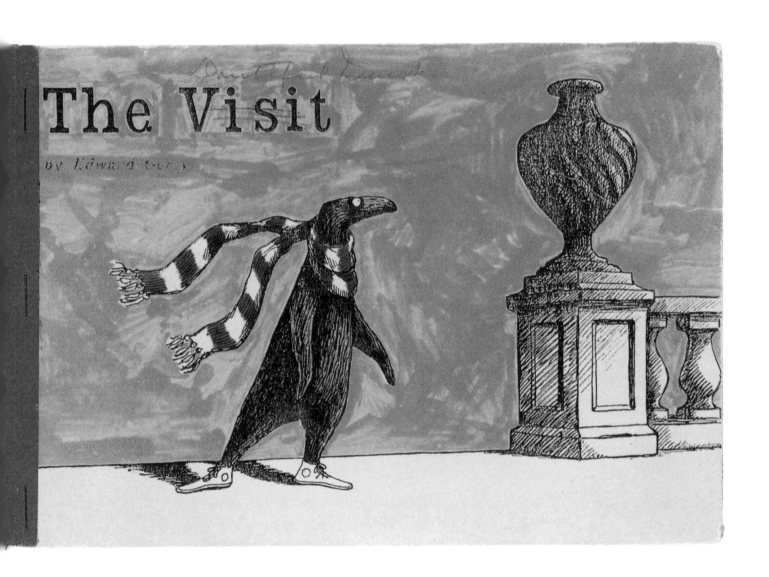

The Visit

by Edward Gorey

Unfinished sketch
for *The Blue Aspic*. 1968.

"As Tsi-Nan-Fu Caviglia
had her greatest triumph to date."

CR: And what about the finished drawings? Sometimes I've seen pencil underneath the ink.

EG: I do a rough sketch, but sometimes it's very rough. It would depend. For instance, if I were drawing a car I would need to draw it fairly elaborately in pencil beforehand.

CR: What about color?

EG: With color, I have a tendency to wish to blow my brains out at some point or other. I always have trouble finishing color. I mean I start out and I put in the colors I like—olive green, and lemon yellow, and lavender. And then I think, "Oh, dear, there are other colors that have to go in this some way or other." But I don't know what colors I want in there. And then I realize I don't want any more color than this at all. And so I sit there.

CR: The color comes after?

EG: Yes. But sometimes I know it's going to be in color.

CR: What about materials?

EG: You want the sad history of my use of materials? I use Strathmore illustration board, 2 or 3 ply depending on what I can get a hold of. And I draw with Pelikan ink and some discontinued pen point from Gilotte. I think I have enough to last me for the rest of my life.

CR: A particular pen point?

EG: I used a lot of different Gilottes. They had one called a titquill pen point. It was very small and, by a brilliant bit of packaging, you could only buy them a dozen at a time on a little card that was wrapped in cellophane. And of course, by the time you got them home, at least three of the twelve were totally useless. One of them would usually last for about a year. Some of them were split in the first place and others you couldn't use for more than about 3 lines. They cost 10 times as much as any other pen point and then they stopped making them. I had a real *crise*.

CR: Have you ever worked with paint?

EG: Occasionally watercolor.

CR: What's the largest scale work that you've undertaken?

EG: Occasionally I've done some work 8½ by 11 inches. I really don't like drawing larger than 6 by 9. When I first started at Doubleday in 1953, I realized that everybody else drew images and then had them reproduced smaller than the original for better effect. But for some reason I've almost never done that. I could tell what it was going to look like if I did it the same size, so I just got in that habit of making it the same size.

CR: What about the backdrops and sets for some of your theater pieces? Did you paint any of them?

EG: Only for my small efforts on Cape Cod. I took one design from an African bead. It was originally going to be meticulous and flat. I was sloshing paint around and I thought, "I'm tired, so I don't really want to go over it and make sure that it's equally thick all over." Besides I didn't have time. So I just left it in that kind of brushy state. No, "painterly." Isn't that what it's called when they talk about Jasper Johns's work? It's "painterly," which means it's sort of sloppy.

CR: Would you ever allow those painted pieces to exist on their own, as works of art, unconnected to the theater?

EG: Most of the stuff I've done for sets I wouldn't.

CR: Your efforts in theater are mainly collaborative, aren't they?

EG: Ordinarily, I don't like collaboration in the conventional sense. You know, "A" writes one line and "B" writes the next

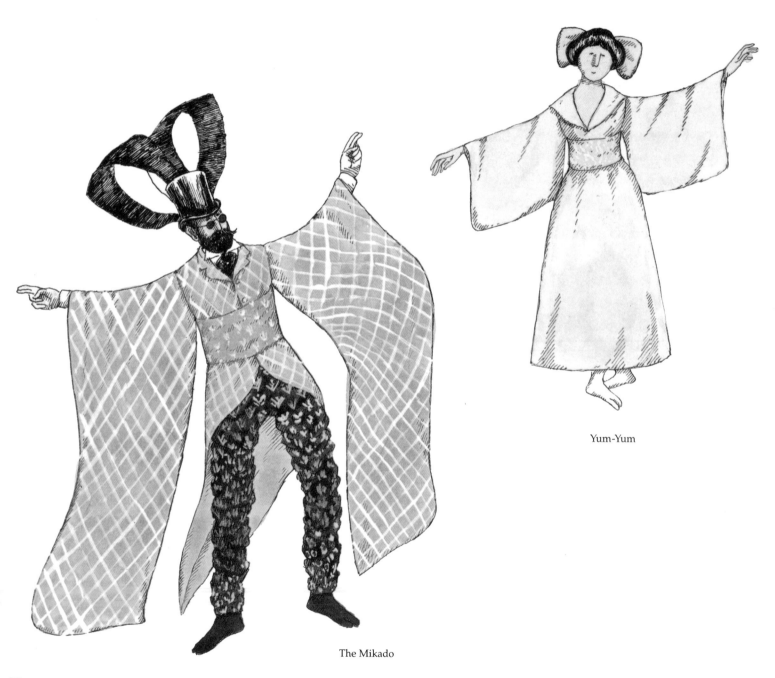

The Mikado

Yum-Yum

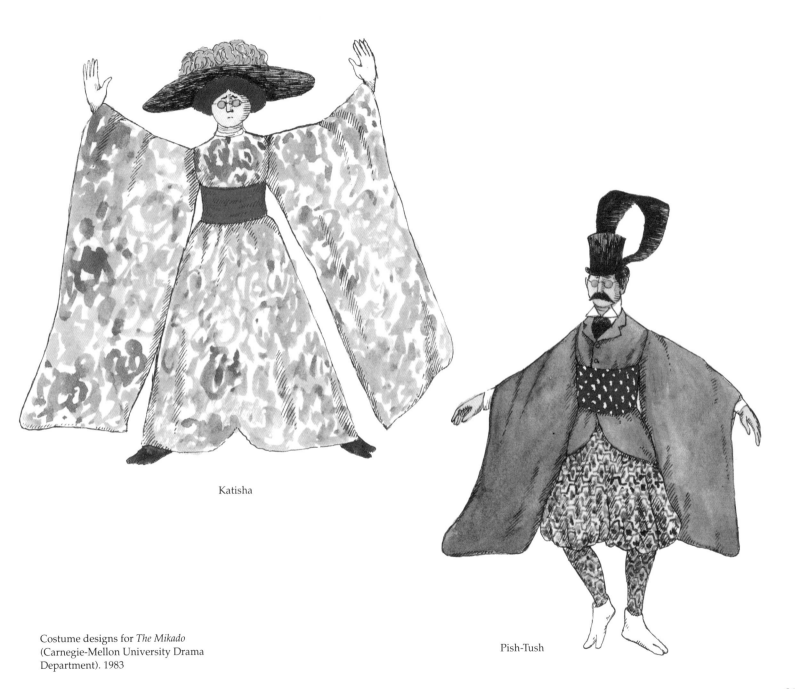

Katisha

Pish-Tush

Costume designs for *The Mikado*
(Carnegie-Mellon University Drama
Department). 1983

31

and "A" writes the third line and "B" writes the fourth. That sort of thing I don't care for at all. I was sent the manuscript to *Treehorn* and I did the drawings and that was it. It was a success and so Florence [Parry Heide] wrote another one. And I did the drawings for that. And she did a third one. And after about 8 years, I did the drawings for that. That's really the extent of my collaboration. The thought of talking to someone on the phone and somebody saying, "Well, I think the person on the left should look a little more . . ." You know, forget it, kids, I don't collaborate. I think everybody has realized that over the years.

CR: What about the ballet with Baryshnikov? Did you collaborate with him?

EG: David Gordon and Misha asked me to work on it. Everybody felt, "Oh, it's got to be black and white, sort of like *Dracula*." We did have a meeting of sorts and I was told by David there was no backdrop, but there was a sofa. And there was a coffin and the lid opened up. I did it in that skewed way that *The Cabinet of Dr. Caligari* is done, and I had the most god-awful time. After I sent in the sketches for the costumes and they started working on them, somebody would call up and say, "Would you mind awfully if we did this?" And I'd say, "No, I wouldn't."

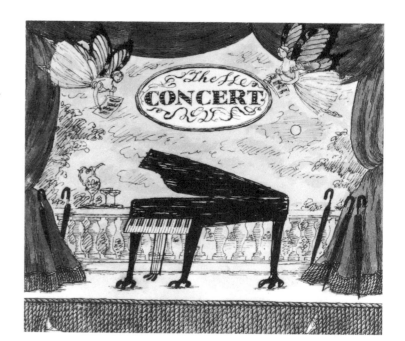

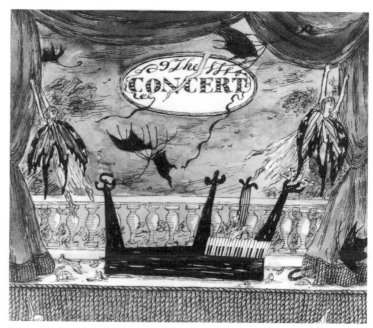

Sketches for drop curtains for *The Concert*, ballet choreographed by Jerome Robbins. November 1981

CR: So you're saying that even the theater and dance pieces, which involve other people, are not really collaborations. What about *Dracula*? Was that at all collaborative?

EG: The guy that was seeing to it that the set was built was somebody that I liked very much, and we talked, but basically there was no collaboration. You know, John Cage will write music for he doesn't know what. And Merce Cunningham will choreograph for he doesn't know what. And somebody else will design costumes for he doesn't know what. And someone else will design backdrops for he doesn't know what. And then it all magically goes together. Or not, as the case may be. Recently, I was reading about the term *bricolage* in reference to primitive society dreams and rituals. They would take things from their daily life, like certain kinds of vegetables or certain kinds of other objects, and they would weave them all together into a mythology. They just took whatever they happened to have at hand, and turned it into a wonderful belief. I feel that there's a lesson for us all in that. It really doesn't matter what you're doing. Just do it. George Balanchine was always saying, "Don't dither." You know, either do it or don't do it. Half of the time he was saying, "I wouldn't do that, dear," and the other half he was saying, "Just do it, dear." He hated people who said, "Oh, I don't know whether I should do this or not" And I think he's absolutely right. The more I go on, the more I feel Balanchine was the great, important figure in my life.

CR: In what way?

EG: Well, sort of like God. There wasn't very much I could take directly from George.

CR: What about your formal education?

EG: I had a good art teacher in high school. And I had a sense of purpose. I was going to be a painter. The fact that I couldn't paint for beans had very little to do with it. I found out quite early in the proceedings that I really wasn't a painter at all. Whatever else I was, I was not a painter.

CR: And by the time you got to Harvard . . . ?

EG: I think I was singularly lacking in any ambition or sense of who I was. There you were in college. And then you got out and tried to get a job, usually in publishing or a museum or something like that.

CR: What did you do?

EG: I hung around Boston for two and a half years. I worked for a man who imported British books, and I worked in various bookstores and starved, more or less, though my family was helping to support me. And then I went to New York for a visit. Doubleday offered me a job. At first I said no, but then I thought, "I'm really not surviving very noticeably in

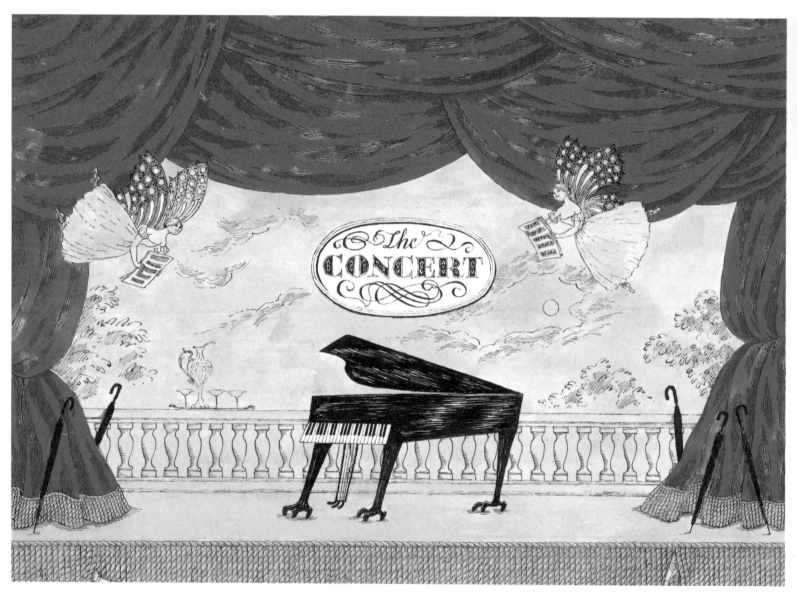

Above and opposite: Drop curtains for *The Concert,* ballet choreographed by Jerome Robbins. November 14, 1981

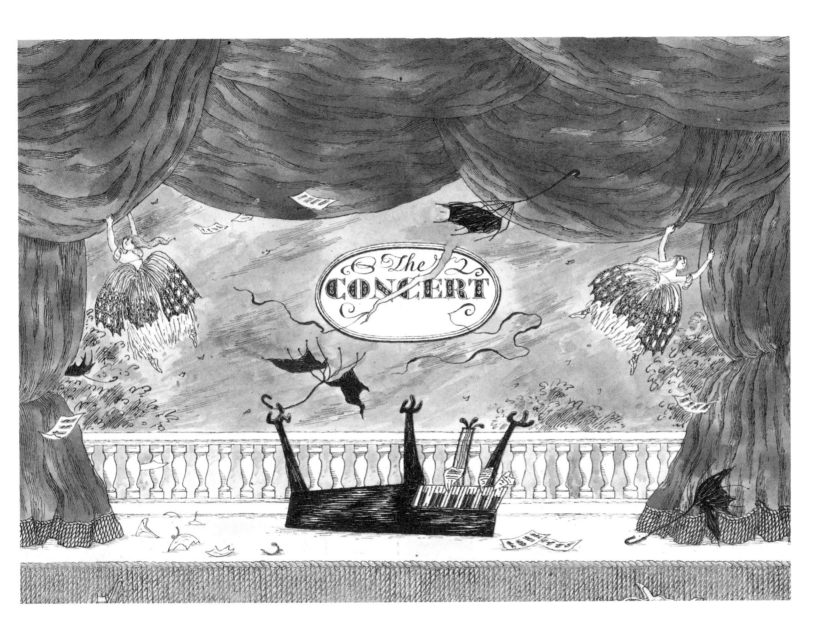

Boston, so I'll move to New York, much as I hate the place." A thought I never lost sight of. It's just too much.

CR: Where did you live?

EG: On 38th Street. I looked in the Village when I first was visiting but I couldn't find anything. And I mainly lived there until I began spending more and more time on Cape Cod around 1964.

CR: I know you read very widely. Almost like cultural foraging.

EG: My reading tastes are so bizarre. Recently, I've been reading Jung and Gurdjieff. I haven't read a novel for a long time. Actually, I did read one. I didn't like it.

CR: Do you still read works from a wide variety of cultures?

EG: Well, it's been different at different times. I'm reading Greek mythology now, which I've never really done. I read a lot of Roman stuff at one point. I've forgotten why. And I've read a lot of Japanese, of course, and a lot of Chinese.

CR: Does haiku influence you at all?

EG: I don't know how much it influences me. It's very difficult to write haiku in English, no matter what they say. Every book of haiku in English that I've read has been absolutely dreadful.

CR: How about the "idea" of haiku? That it's a concise literary form, and somewhat oblique, like your work?

EG: Well, I love the idea.

CR: And French literature?

EG: Occasionally I think, "I majored in French in college and I haven't read anything in ten years." And so I'll read a few books in French. And then that will simmer down. I adore Flaubert, I read him over and over and over again, albeit with a good deal of boredom, and I think, "Why am I reading *Madame Bovary* again? Why am I reading *Salammbô?* It's the most boring novel ever written." And *A Sentimental Education* is maybe the great French novel of the nineteenth century. But I do think it was Flaubert who suddenly decided, "Oh, well, if I don't anguish over every single word, hell will freeze over or something."

CR: Are there contemporary fiction writers that you read?

EG: I don't think so anymore. There used to be. I used to get everything from England and I was up on everything. I never

read Americans that much. I haven't discovered any absolutely zippy English novels that I'm determined to read through at this point. Oh, I've read all of Agatha Christie about five times.

CR: Which other authors are important to you?

EG: I think a man named E. H. W. Meyerstein, who died around 1950, may be one of the great twentieth-century authors. Gollancz issued his last three novels back in the fifties. He's one of the truly great eccentrics. He wrote endless reams of poetry in terza rima which I've never been able to read. He wrote a lot of very strange works. He writes about a kind of really outrageous underworld—half of his characters are totally bookish and run secondhand bookstores or something. And other people are off in the underworld doing all sorts of rather creepy things. And there's a wonderful lady who almost nobody's ever heard of, called Mrs. W. K. Clifford. I don't know anything about her, but she wrote some really blood-curdling novels in the early 1900s and up till about 1930. My favorite of all, though, is *The Fairchild Family*. You know, the kids had quarreled, so they're taken off to see a corpse which is decayed and completely hanging. It was parody. But I must say, I read it seriously and got quite caught up in it. And *Uncle Tom's Cabin*. Everybody has an idea that it's this ludicrous, melodramatic book. It's a terrific book. And I've read most of Dickens. I quite adore him. I tend to like the books of his that aren't as popular. I think he creates real nail-biting situations, like when Oliver goes into London, and you think, "No, no, Oliver, don't go! They're going to get you!" Unfortunately, I came across an anecdote about Dickens, which I won't repeat, and I haven't been able to read any since.

CR: What do you watch on television?

EG: At the moment I'm watching "Dead at 21" on MTV, their first dramatic series, if you can call it that, which I find a joy. And I watch the trash movies on USA cable. And I watch reruns of sitcoms.

CR: "Cheers" and "Honeymooners"?

EG: "Mary Tyler Moore" is practically the only one of the classic sitcoms that I really love. I've watched "The Dick Van Dyke Show" occasionally. "The Honeymooners" I don't care for. I don't care for "Lucille Ball" all that much. I liked "Cheers." But the relationship between Shelley Long and Ted Danson just drove me right up the wall.

Pages 38–39: From *The Listing Attic*. 1954

From the bathing machine came a din
As of jollification within;
 It was heard far and wide,
 And the incoming tide
Had a definite flavour of gin.

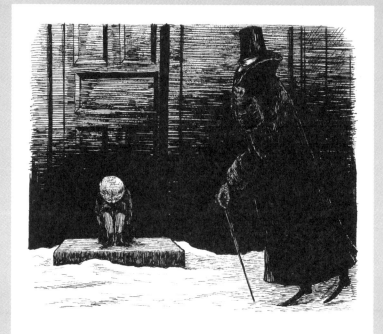

Augustus, for splashing his soup,
Was put for the night on the stoop;
 In the morning he'd not
 Repented a jot,
And next day he was dead of the croup.

There's a rather odd couple in Herts
Who are cousins (or so each asserts);
 Their sex is in doubt
 For they're never without
Their moustaches and long, trailing skirts.

Ce livre est dédié à Chagrin,
Qui fit un petit mannequin:
 Sans bras et tout noir,
 Il était affreux voir;
En effet, absolument la fin.

A is for AMY who fell down the stairs

B is for BASIL assaulted by bears

CR: It sounds like Agatha Christie, Greek mythology, the movies, and television all contribute . . .

EG: Right. You never know where you're going to find some wonderful tidbits.

CR: Is there anything we haven't covered?

EG: Well, most interviewers don't ask me the questions I think they should ask me.

CR: Like?

EG: Oh. Well now, of course, you're forcing me into a corner. Nobody ever asks my theory on art and literature.

CR: I did mean to ask that.

EG: Well, I realize that I'm sort of betwixt and between. I do think there is something to be said for art which is just sort of lukewarm. I remember somebody once telling me that there is a phrase in the Beatitudes, in the French version, that literally translated means "Blessed are the nonchalant." Well, the kinds of things I'm attracted to are nonchalant.

From *The Gashlycrumb Tinies or, After the Outing.* 1963

Opposite: Drawing for the animated title sequence of *Mystery!* television series, c. 1980

Page 42: From *The Unstrung Harp.* 1953.
"Mr. C(lavius) F(rederick) is, of course, the well-known novelist."

Mr. Earbrass Jots Down a Few Visual Notes: The World of Edward Gorey

by Karen Wilkin

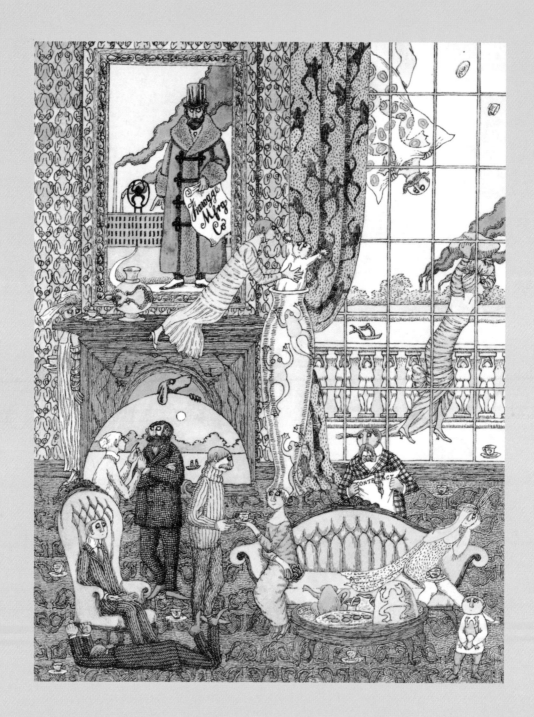

Mustachioed men in ankle-length overcoats; elegant matrons with high-piled hair; athletic hearties in thick turtlenecks; imposing patriarchs in sumptuous dressing gowns; kohl-eyed wantons with alarming décolletages and nodding plumes; solemn children in sailor suits and pinafores; frivolous housemaids.

These are the inhabitants of an utterly unreal but wholly believable universe instantly recognizable, at least to initiates, as the world of Edward Gorey. The time seems to be the Edwardian era, certainly some time before World War I, although occasionally a character appears to be a fugitive from someone's vision of the 1920s. The place seems to be England, judging by the phraseology and the way people occupy their time, although on occasion, small town America is suggested. Gorey's characters often appear to be participants in an endless house party where something appalling has just happened or is about to happen. It's all quite stylized, distanced, like a series of stage tableaux or events at once indelibly etched in the memory and distorted by the passage of time.

For Gorey's admirers, this band of crypto-Edwardians are old friends, known intimately from his distinctive little books of brooding pen-and-ink drawings and elliptical narratives, dramas with such enigmatic titles as *The Listing Attic*, *The Doubtful Guest*, or *The Willowdale Handcar*. These handsome volumes with their intimate formats, their meticulously cross-hatched illustrations, and their elegantly hand-lettered text, have attracted a following since 1953, when Gorey

From *The Unstrung Harp*. 1953.
"Mr. Earbrass was virtually asleep when several lines of poetry passed through his head."

Opposite: *Untitled*. 1994

published *The Unstrung Harp,* an achingly funny, wistful story about the perils of the literary life, exemplified by the labors of C. F. Earbrass, "the well-known novelist." The ratio of text to drawing in *The Unstrung Harp* is higher than in most of Gorey's subsequent books, but otherwise it already embodies everything that has become synonymous with his name: painstaking drawings with an eloquent orchestration of hatchings and tickings, marvelous period details of

costume and setting, a narrative that leapfrogs melancholy, and an author who manifestly

Gorey's offbeat visions of a perhaps in recent years, as the animated titles that *Mystery!* series, but their inventor than a household word. (Gorey's who comb secondhand bookstores covers he designed for Doubleday, career.) The magnates and dowagers, who enliven the *Mystery!* titles are, in Gorey's Edwardian England. There are, correct bourgeois clerks, dizzy flappers, with glasses, muffled in an endless scarf, turned away from the viewer—declares companions, although this figure can not always as a surrogate for the author, Nonhuman creatures, both threatening and

from the precise to the unexplained, a tone of vague delights in both visual and linguistic oddities. nonexistent past have reached a wider audience introduce the Public Broadcasting System's remains something of a cult figure, rather fans, however, are the kind of true enthusiasts for such collector's items as the unsigned book and Grosset and Dunlap, in the early days of his debutantes and policemen, victims and malefactors any event, only a small part of the population of as well, flamboyant opera singers, lithe ballerinas, sinister ne'er-do-wells, and more. A bearded man a massive fur coat, and high-top sneakers—usually Gorey's own presence among his invented appear in many contexts and many guises, and in spite of the evidence of fur and footwear. benign, also wander through Gorey's interiors and

landscapes: indolent cats, cheerful dogs, amiable (and admonitory) hippopotamuses, gawky birds, talking alligators. Some are appealing, even cuddly, and some, downright repulsive. There are amorphous but friendly beasts, part stuffed animal and part newt, and other indescribable things you hope not to come upon in the dark. Inanimate objects—urns, topiary, umbrellas, pen points, not to mention statues and snappy motorcars—play significant parts as well.

The settings are as unmistakable and as unsettling as the beings that populate them. Most of Gorey's tales are set

Above: *Self-Portrait with Flying Dog.* May 26–27, 1978

Opposite: From *The Tunnel Calamity.* 1983

in town or country houses with vast rooms lined with wood paneling, lit by tall, lace-curtained windows. Drawing rooms have marble mantlepieces and imposing tufted armchairs; bedrooms are furnished with massive four-posters. Long corridors lead to steep staircases; doors reveal vistas of more doors or open onto terraces with balustrades and decrepit statuary. The surroundings are streets with rows of iron railings, or bleak expanses of countryside punctuated with clumps of trees, mazes, and garden follies.

Gorey's settings, like his period characters, demand words no longer in common use. They are rooms where antimacassars protect the upholstery, aspidistras fill the urns, pelmets hang at the windows, and the whatnot is decorated with ormolu; they are places where gentlemen wear monocles, grandes dames peer through lorgnons, and young ladies adjust their aigrettes. Even when— or perhaps especially when—their inhabitants are absent, Gorey's settings are ominous. His drawings, in fact, often gain in authority when his gang of period characters disappears, so much so that some of his most powerful images are of empty rooms and almost deserted

landscapes. With or without figures, it all seems very literary, even stagey, so that it comes as no real surprise to learn that Gorey not only lacks firsthand experience of the upper-class life in the Edwardian period, but has never even been in England. His vision of the world he has claimed as his own is derived principally from a lifetime of voracious reading.

When Gorey illustrates texts by other writers, he responds with images no less engaging but often quite different from his usual "Edwardian" (both in the sense of the British monarch and of Gorey himself) inventions, not only in

Above and pages 49–50: From *The Secrets: Volume One, The Other Statue*. 1968

 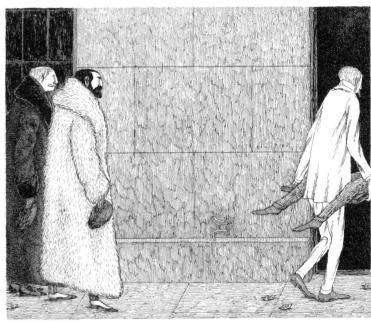

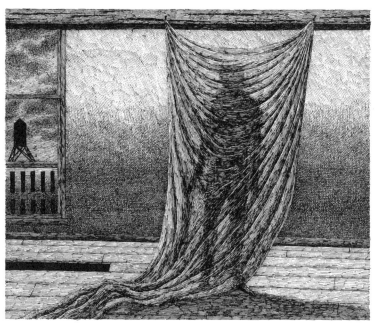 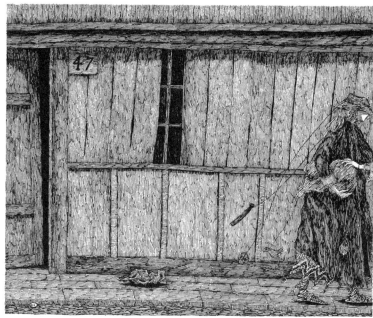

subject, but in formal terms as well. He has turned his attention to works by writers ranging from Edward Lear to Samuel Beckett, and from Virginia Woolf to T. S. Eliot, as well as a series of children's adventure novels by John Bellairs, the Brer Rabbit stories, and Aesop's fables, with remarkably diverse results. The illustrations for Beckett, for example, have almost nothing to do with any of Gorey's other works, but instead suggest Surrealist prototypes. "Illustration" may not be the right word, since Gorey's contributions consist of tiny insertions in the page, images perhaps drawn from turn-of-the-century commercial art, transformed into apparently abstract patches of texture and pattern. The Brer Rabbit stories elicited spare line drawings with plentiful use of the white of the paper, unlike Gorey's more usual stage-set–like "windows" into a fictive space, while Edward Lear's classic poems, "The Jumblies" and "The Dong with the Luminous Nose," called up a band of agile little figures vaguely reminiscent of the 1840s—sailors in striped jerseys, ladies and gentlemen in fantastic bonnets and tailcoats, and other personages quite unlike Gorey's usual cast of characters. They sail on oceans and bustle about in landscapes that are similarly atypical, but are among the most inventive, tonally complex of his drawings. The illustrations for Muriel Spark's children's book, *The Very Fine Clock,* made at about the same time as the drawings for the Lear poems, are vintage Gorey, with Spark's story translated into his familiar realm of eccentric men with mufflers, paneled rooms, confusing passageways, and an unforgettable scene of what appears to be a picnic in a moon crater.

Something similar occurs when Gorey changes disciplines. When he creates stage sets and costumes or designs book jackets, the shift in scale and function can cause him to draw upon new lexicons of images and associations—without, it should be pointed out, weakening the stamp of his particular vision. Of course, in Gorey's best-known theater effort, the sets and costumes for an extremely successful Broadway production of *Dracula,* he exploited to the fullest the sinister overtones of his habitual imagery.

It is interesting to see how different in mood Gorey's occasional colored drawings, with their transparent watercolor washes, are from the most characteristic of his rather disturbing pen-and-ink drawings. Generally, when Gorey works in something other than black and white, his images seem more playful and relaxed. Of course, cause and effect may be reversed here, since when Gorey uses color, rather than restricting himself to the black and white of pen and ink, it is usually because he is working on stage designs or book jackets, or single set pieces intended as magazine illustrations or covers—works whose function is intrinsically more decorative than the images in his odd little books. Color, in any event, never seems to be Gorey's primary concern. He is adept at orchestrating a range of hues, but it is clear that colors

Above and pages 53–54: From *The Very Fine Clock* by Muriel Spark. 1968

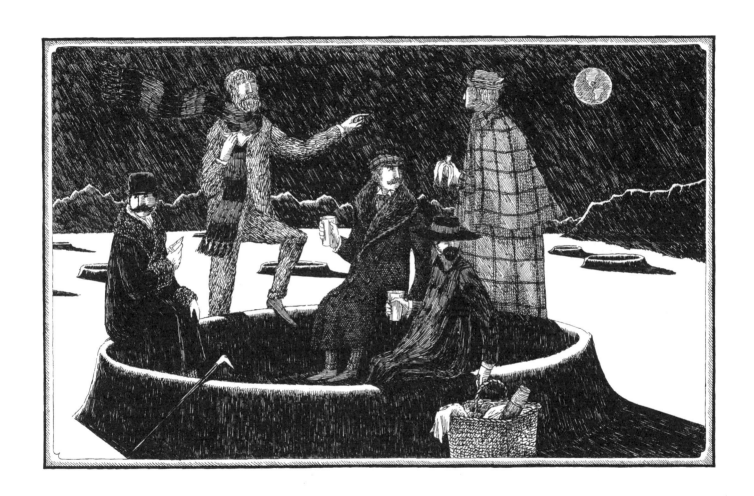

are simply additions to structures conceived as line drawings; as a rule, he uses chromatic color to emphasize particular elements, to separate parts of a costume, or to accent aspects of a setting, rather than to intensify emotional temperature or drama, as he does with the tonal ranges of his pen-and-ink drawings. Through masterly variations of density and pattern, achieved by altering the direction and spacing of repetitive ink lines, and a virtuoso deployment of white space, Gorey is able to extract more "color" from black ink on white paper than he is from a whole spectrum of pigments. It is as though, as many great photographers are said to have done, he thinks in terms of tonalities, in black and white.

What remains constant in Gorey's art, whatever its purpose or medium, is the coherence of the appearances and the mores of his invented worlds. In the most arresting of his images there is, too, an overwhelming intensity, a sense of the artist's ferocious concentration on each stroke of the pen, on each detail evoked, no matter how economically. Unlike the majority of traditional illustrations, the best of Gorey's drawings could easily stand on their own as independent works of art, detached from the strange narratives that provoked them, their mystery wholly conveyed by purely visual means. (This is not to discount the significance or charm of Gorey's writing.) What chiefly identifies his work as book art is its intimacy. His drawings reward scrupulous attention and are most eloquent when they are examined close up, at leisure—as when you hold a book. They have the uncanny, stop-time quality of vintage photographs and the grainy textures and tonalities of engravings from the era before the photographer displaced the draftsman as the supplier of images for magazines and newspapers. Like old photographs and illustrations—which frequently serve Gorey as indirect sources—his drawings seem at first to bear witness to a vanished era, but the longer you look at them, the more unlikely they seem. They are plainly *made,* invented objects that are the product of a particular hand and a particular imagination.

Gorey's drawings and text alike have provoked such adjectives as "whimsical," "macabre," "fey," and "Gothic," none of which seems quite accurate. His vision seems closest to the tradition of Victorian nonsense, to that of Lewis Carroll or perhaps even to a greater degree, to Edward Lear who, like Gorey, invented images to accompany his own verses. Gorey has a particular affinity for Lear, whose rollicking nonsense poems he has known since childhood. Though a century divides them, the two men have a good deal in common, which may account for why Gorey's illustrations of Lear's poems are so inspired. In addition to the similarities in their work (and their common first name), they share a cultivated eccentricity, splendid beards, an affection for cats, and ominivorous appetites for obscure information. (In contrast to the peripatetic Lear, however, Gorey prefers to travel as little as possible; since leaving New York in 1983, he has remained more or less immovably fixed in his Cape Cod town.) Like Carroll and Lear, Gorey has devised a parallel

'Death and Distraction!' said the Pins and Needles. 'Destruction and Debauchery!'

Almost at once the No. 37 Penpoint returned to the Featureless Expanse.

It encountered the Glass Marble, but neither recognized the other.

The Two-Holed Button concealed its apprehension.

universe with its own laws and attributes. Like his Victorian predecessors, too, he describes the characteristics and conventions of his invention very precisely, with great seriousness and conviction, never suggesting for a moment, no matter what happens, that anything out of the ordinary is going on. In Gorey's *The Inanimate Tragedy,* for example, we are told that "The Knotted String appeared and the Two-Holed Button fell senseless," a declaration that is simply one of a series of straightforward assertions of the completely illogical, very much in the spirit of Carroll's Looking Glass world or Lear's limericks. Think of the Red Queen informing Alice, "Now, *here,* you see, it takes all the running *you* can do to keep in the same place," or Lear's Old Man with a Beard's declaration:

> It is just as I feared!
> Two Owls and a Hen,
> Four Larks and a Wren,
> Have all built their nests in my beard.

Another, more recent analogy—although one still belonging to the past and to an obsolete art form—could be made with Buster Keaton's brand of silent, deadpan humor. Keaton's film persona does absurd or dangerous things as though they were perfectly reasonable, with fierce concentration and great solemnity. The connection between Keaton and Gorey is sometimes surprisingly direct. *The Willowdale Handcar, or the Return of the Black Doll,* for example, is the saga of three people who travel for months, through changing seasons, on a railroad handcar. They cross an immense plain, visit local curiosities, and witness local disasters before they vanish into a tunnel. The book, which includes a group of Gorey's most dramatically composed landscapes, such as the distant view of the trestle over Peevish Gorge or a close-up of Wobbling Rock, reads and looks like an homage to one of Keaton's short films. Not only are Gorey's characters usually as straight-faced as Keaton at his most absorbed, but so is the tone of his text, a device that serves, as it does in Keaton's films, to emphasize the unlikeliness of the action and to underline, as well, the hilarious earnestness of the narrative.

Unlike Carroll or Lear, or even Keaton, Gorey delights in the sinister and the downright gruesome. Perfectly horrible things happen to children in his books. In literary forms usually associated with lighthearted amusements— limericks, rhyming couplets, and alphabet books—little boys and girls are abandoned, lost, mislaid, preyed upon, or simply done away with. Sometimes their doom seems arbitrary—in the alphabet books there is often one catastrophe for

Opposite: From *The Inanimate Tragedy.* 1966 Pages 58–60: From *The Willowdale Handcar, or The Return of the Black Doll.* 1962

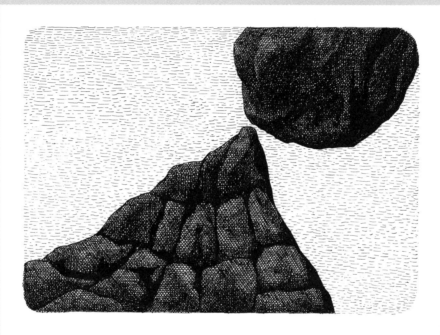

An undated fragment of the 'Willowdale Triangle'
they found caught in a tie informed them that
Wobbling Rock had finally fallen on a family
having a picnic.

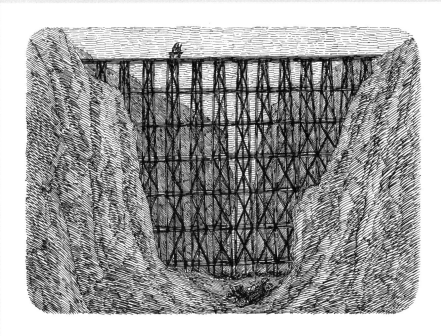

From the trestle over Peevish Gorge they spied the wreck of a touring car at the bottom. 'I don't see Dick's friend anywhere' said Harry.

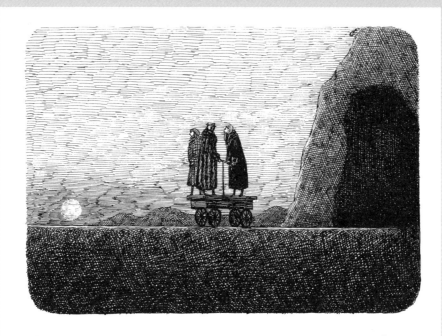

At sunset they entered a tunnel in the Iron Hills and did not come out the other end.

each letter. Or, in the best tradition of fairy tales, the children are sent on innocuous errands by insufficiently attentive guardians and come to hideous ends through sheer mischance, while at other times, in the tradition of the moral lesson, they wander off or disobey strict injunctions, with disastrous results. Gorey's accounts of misadventure are like Victorian cautionary tales gone awry. They are not wildly comic in the manner of Hilaire Belloc's imitations of the genre, but they are still extremely entertaining, rather than grim. (Gorey has been working on illustrations for Belloc's verses, on and off, for some time.) In Gorey's versions of the idiom, the Awful Consequences are seen not as warnings, but as more or less normal and not particularly tragic. Children are the most frequent victims—the obvious ones, Gorey says—but adults are not exempt. People disappear into tunnels never to emerge or are carried off by monstrous creatures; they do one another in, go mad, or fling themselves from parapets.

Even when none of this is spelled out, Gorey's ambiguities leave us expecting the worst. The last drawing in *The Curious Sofa*, one of his earlier books, shows nothing especially frightening—just the corner of a sofa with peculiar legs and something indecipherable on the floor—but the caption reads: "When Alice saw what was about to happen, she began to scream uncontrollably . . ." Yet this dire ending comes neither from one of Gorey's warped cautionary tales nor from a macabre history of "the deranged cousins" or "the loathsome couple," but from a spoof of the pornographic novel, an exercise in cheerful silliness. (The book is cherished by Gorey fans for the line "Still later, Gerald did a terrible thing to Elsie with a saucepan.")

On the surface, it is all very gloomy, yet none of the apparent horrors really seem to matter. That the orphaned protagonist of *The Hapless Child* (published in 1961, the same year as *The Curious Sofa*) is run over by her long-lost father and dies unrecognized in his arms, is not so much poignant as mawkish, the stuff of Victorian melodrama. Gorey invokes

Above and overleaf: From *The Insect God*. 1963

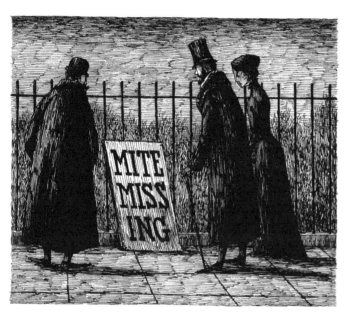

"O what has become of Millicent Frastley?"

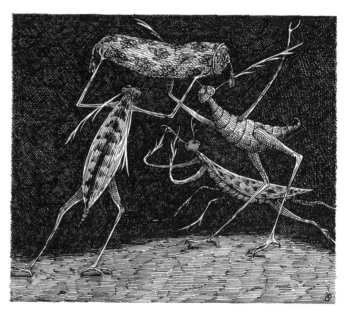

"They stunned her, and stripped off her garments."

all of those tragic innocents of nineteenth-century literature—Little Nell, the Little Matchgirl, Little Eva, Beth, and their counterparts—all consigned to early deaths, either from abuse and drudgery or from sheer excess of virtue. Gorey's most extravagant satire of the type, *The Pious Infant,* is the story of a four-year-old of such surpassing (and priggish) godliness that he would have given pause even to Victorian readers; the last moments of the hero are described graphically: "God loves me and has pardoned all my sins. I am happy!" he says, just before falling back "pale and still and dead."

The Hapless Child has a dramatic plot, clearly meant to remind readers of a well-known type of nineteenth-century novel for girls—Frances Hodgson Burnett's *Sara Crewe* is a model of its kind—in which a young heroine is wrenched, usually by the death of a parent or a reversal in family fortune, from a life of privilege and plunged into deprivation and misery. In *The Hapless Child,* Gorey's staccato rhythms, laconic narrative, and stylized drawings, like the plot itself, simultaneously obey the conventions of the genre and mercilessly parody them, underscoring both the inherent pathos of these tales and their inadvertent over-the-top absurdity. The story begins: "There once was a little girl named Charlotte Sophia," whose parents were "kind and well-to-do." This happy state didn't last long. After Charlotte Sophia's father, a colonel in the army, was reported killed in a native uprising, "her mother fell into a decline that proved fatal." Soon after, "her only living relative, an uncle, was brained by a piece of masonry."

This mishap provides Gorey with the grist for one of his most powerful and economical drawings, an image at once grim, beautifully drawn, and funny. The moment depicted is the moment of maximum drama, just *before* the effect of disaster. An elegantly dressed man in a fur-collared overcoat, spats, and a silk topper is seen from the back, his upright figure collapsing into a loose curve as a chunk of stone lands on him; he has dropped his walking stick, but his tall hat has not yet been crumpled. The descending arc of his well-tailored, carefully shaded back contrasts dramatically with the horizontals of crisp railings and shaggy shrubbery, and with the rigid vertical of a building, its edge defined by a stack of massive, rusticated corner stones, perhaps the source of the fatal missile. An armless statue of a male nude, delicately outlined in the background, repeats and reverses the uncle's pose, rapidly expanding the shallow space of the drawing.

After her uncle's demise, Gorey continues, Charlotte Sophia was placed in the obligatory brutal boarding school of such stories. Hodgson Burnett's Sara Crewe, for example, was sent to Miss Minchin's Select Seminary for Young Ladies. There, sustained by pride, relentless goodness, and selflessness in the face of adversity, Sara was rescued and went on to still more selfless deeds, but poor Charlotte Sophia had no such luck. Fleeing the dreadful school in despair, she was

carried off by a man who "brought her to a low place" and "sold her to a drunken brute" who put her to work making artificial flowers. Escaping from the brute, she was struck by the car driven by her father, who wasn't dead after all, and had returned to search for her. It should be heart-rending, but somehow it isn't. The drawing of the father, unrecognizable in goggles, a motoring cap, and a leopard coat, bolt upright in his open car—an early electric runabout?—is sinister and grotesque. The final image, where the father, still in goggles and leopard, kneels in the snow, holding a shaggy, boneless creature more like a rag doll than a child, irresistibly recalls Oscar Wilde's celebrated quip: "One must have a heart of stone to read the death of Little Nell without laughing."

No matter how odd or, at times, pointless the premise of his plot—a child abducted and sacrificed to the Insect God, a family persecuted by an unnameable, muffler-swathed, apparently immovable creature, an opera buff driven mad by his passion for a diva, the discovery by a former film star that his lions have been sent to Ohio for the winter—Gorey tells his stories matter-of-factly, in elegant declarative sentences whose connections are often, to put it mildly, oblique. Like novels reduced to absurd essentials, these lists of apparent non sequiturs turn out to be relentless in their logic: this happened and then *this*—no matter how improbable—happened as a result. Gorey's dry assertions of the

unlikely have been compared to Dadaist and Surrealist poems, experiments in the irrational composed of "found" lines assembled from random sources, their sequences apparently dictated by the operation of chance or the unconscious. Some of Gorey's texts have the unfocused quality of sentences from phrase books, no doubt helpful individually in particular situations, but bizarre when read in the rather arbitrary order of their presentation. Others exploit the stilted constructions and unintentional gaffes of over-literal translations. Several of Gorey's books are, in fact, phrase books for imaginary circumstances. One, supposedly "Englished from the Conton dialect," offers the useful sentence "There has just descended one shower of rain," in tandem with a drawing of a man with a waxed moustache, wearing a Chinese robe and high tops, who illustrates the concept by pointing to an old-fashioned upright telephone; another, a dialogue between a pair of acrobatic anthropomorphic dogs in sporty ribbed turtlenecks, includes such dubious exchanges as "What is the extra charge for a deck chair?" "I feel sick."

Above: Odilon Redon. *Strange Flower (Little Sister of the Poor)*. 1880

Back cover for *The Iron Tonic: or, a Winter Afternoon in a Lonely Valley.* 1968

The guests who chose to stay aloof
Lie wrapped in rugs upon the roof.

Above and pages 67–68: From *The Iron Tonic: or, a Winter Afternoon in a Lonely Valley*. 1968

A fugitive and lurid gleam Obliquely gilds the gliding stream.

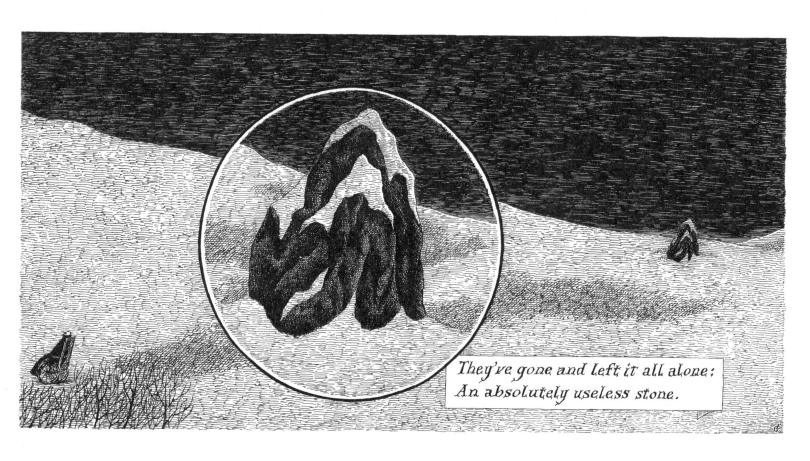

They've gone and left it all alone:
An absolutely useless stone.

Although in Gorey's usual way of working, text—a complete, polished text, at that—always precedes image, his drawings are not so much illustrations of his stories as parallel accompaniments, their relation to plot frequently as skewed and elided as the sequences of sentences themselves. Details of costume and setting may be precise, but just what is going on remains open to interpretation. What happens between events simply isn't mentioned. Significant things often seem to be occurring off to one side, in the distance, or just out of sight. Gorey plays with this notion in *The Iron Tonic: or, a Winter Afternoon in a Lonely Valley*, which is set, unlike most of his works, in a vast, chilly landscape. He abruptly shifts the viewer's perspective of the snowy fields and bare woods where the guests of "the grey hotel" wander by inserting circular enlargements of important details into the sweeping panoramas. The effect suggests that a magnifying lens has been placed over part of the drawing, yet the images that are revealed are dislocated, divorced from their apparent context, and frequently, no more intelligible for having been enlarged.

Both Gorey's texts and drawings are extraordinarily willful, as mannered, in many ways (and as good company) as their creator is personally. His carefully honed, disorienting narratives, frequently peppered with obscure words, like his insistently cross-hatched and patterned drawings, can seem obsessive to the point of being overwrought, yet at the same time their wit and intelligence are so palpable, their humor so delightfully offhand, that the obsessiveness seems perfectly acceptable and charming, as the hallmark of a remarkable individual. Yet immediately seductive as Gorey's typical images and texts can be, their real charm—and substance—is revealed most fully not at first meeting but over time. Unexpected pleasures appear—layers of reference and subtle flirtations with an astonishing range of precedents. Even the most apparently straightforward of Gorey's efforts prove, on longer acquaintance, to be far more complex than they seem when first encountered. Initially, the special qualities of his signature style are so overwhelming that you simply recognize familiar figures and settings the way you do the stock characters and situations of the commedia dell'arte or a television sitcom. The period families and their entourages, the suffocating rooms and stony facades, the neglected terraces and overgrown gardens, along with the lolling cats, the lumbering beasts, and the creepy unnameables, all rendered with careful hatching, patterning, and shading, conspire to signal "Gorey" almost before you can decipher the clues to the narrative. Yet soon fleeting—and sometimes not so fleeting—allusions to other art and other literature begin to declare themselves.

Gorey draws upon astonishingly rich, diverse sources, both literary and visual, ranging freely and easily between past and present, East and West, the fine arts and popular culture, from the most cultivated of esoterica to the most

accessible of the vernacular. Gorey majored in French literature at Harvard, but he appears to have read everything and to have equal enthusiasm for classic Japanese novels, British satire, television reruns, animated cartoons, and movies both past and present, good and not so good. His knowledge of films is as wide-ranging and exhaustive as his knowledge of literature, and his taste in art is just as eclectic. He has probably looked hard at as much serious art as he has devoured fiction and nonfiction, but he is as likely—or more likely—to find suggestions for images in newspaper sports photos or old magazine illustrations as he is in the work of painters or illustrators from the past or the recent past.

Gorey is a somewhat hit-or-miss but discriminating collector who lives with a small, predictably eclectic collection: a selection of fine drawings and prints by nineteenth- and twentieth-century modernists from Berthe Morisot to Balthus, a group of nineteenth-century amateur landscapes, some vintage photographs, and a couple of treasured illustrations for Don Marquis's *Archy & Mehitabel* by George Herriman, the inventor of Krazy Kat. Most of the works are hung in locations that at first sight seem perplexing, until you realize they are places that he passes often, as he moves from his small workroom to other frequently used parts of his house. Some of the best drawings in his collection appear to be hung too high, but they often turn out to be at a convenient eye level for their tall owner.

Gorey is an inveterate collector—"amasser" would be a more precise word—of a truly astonishing number of other things, some of whose functions or provenances can only be guessed at, all of which compete for space on his crowded bookshelves, lurk in boxes, hang behind doors, or, on occasion, adorn his person. He is fond of cats, as well, and shares the house with about half a dozen of them, sometimes more, sometimes fewer, at various levels of domestication. Some of these myriad objects—and cats—find their way into Gorey's drawings, altered in scale or meaning, or turned into lively characters. Just as you think you find a resemblance between a striped creature draped companionably across the kitchen table and a relaxed, smiling cat from one of Gorey's colophons, or recognize one of the illustrations for T. S. Eliot's *Old Possum's Book of Practical Cats* in another, less passive feline, you find, as well, that some of the ancient stuffed toys on a top shelf have a marked relationship to the non-animate creatures—the limp, armless black doll or the lumpy pachyderms—who populate Gorey's books.

Longer acquaintance with Gorey's work makes it plain that all of these extraordinary sources—and a great deal more, as well—in various combinations, inform both his art and his writing. He is a master synthesizer who takes pleasure in playing games with allusions, some relatively evident, some intelligible only to Gorey himself, and some decipherable by anyone (unlikely as it may seem) with Gorey's own catholicity of taste and his breadth of experience in

indulging that taste. There is an enormous sense of achievement in recognizing one of Gorey's more obscure references, a sense of having been admitted into a select company, but at the same time, such recognition also makes you aware of how many other allusions you might be missing. (This ability of Gorey's works to delight and puzzle simultaneously may help to explain why he has remained largely a cult figure, in spite of his forays into more popular media. He is most treasured by audiences who get a least some of his more obscure jokes, but he is not what is sometimes called a "crossover artist" who appeals to a wide public at many different levels.)

Often the connections between Gorey's works and his stimuli are very oblique, indeed. He has spoken of his affection for E. F. Benson's Lucia books, a series of delicious satirical comedies of manners about the complications of social life in an English village in the 1920s. The main characters might have stepped from one of Gorey's drawings: Lucia herself (Mrs. Emmaline Lucas), a pillar of upper-middle-class society with pretensions to the artistic, and her devoted friend, the faithful Georgie, who plays piano duets with her, experiments with the latest in men's fashions, and does needlepoint in his leisure hours. There is a pair of frankly philistine retired army and navy types, an internationally acclaimed opera singer, "Quaint Irene," who wears men's clothing and paints—a whole village full of foible-riddled, unforgettable types. To reread Benson's novels after looking at a good deal of Gorey—or vice versa—is to keep catching

glimpses of tenuous connections. In Gorey's *The Lost Lions,* for example, Hamish, a "beautiful young man" who becomes a film star as a result of opening "the wrong envelope," and later gives up the cinema to raise lions, seems strangely like a minor character in Benson's book about Lucia's unsuccessful campaign to enter London society: a beautiful young film actor with a lion cub on a leash. His fondness for the Benson books notwithstanding, Gorey has made only one drawing directly related to the Lucia series,

From *The Lost Lions.* 1973.
"He devoted himself to raising more lions
and working at his diaries."

a small, rather uninspired illustration for an an article he wrote about the novels when they were republished. What is more interesting is that he drew a map of Tilling, the village where several of the books are set, carefully worked out from descriptions, on a page of sketches for a completely unrelated work, *The Epiplectic Bicycle.*

The enchanting stage sets, costumes, and program cover Gorey conceived for a production of Gilbert and Sullivan's *The Mikado* are typical of his ability to synthesize a believable world from an unlikely assortment of sources. His vision of the town and population of Titipu is a delicately balanced gallimaufry of, among other things, traditional Japanese prints, turn-of-the-century postcards of English "watering places," the posters of Henri de Toulouse-Lautrec, and a famous photograph of Lautrec himself in Japanese costume. Gorey's costumes are an amalgam of British good taste and Kurasawa. It is all done with a light touch, in keeping with the spirit of the operetta, but none of it is arbitrary or trivial. The playful conflation of East and West perfectly complements the Victorian conception of a Japan that for all its ostensible exoticism is as English as the England of its authors, and at the same time reminds us of how important the influence of Japanese prints was for some of the most adventurous artists of Gilbert and Sullivan's day. The result is not pastiche, but unmistakably "Gorey."

The Mikado is the invention of a complete polymath with an astonishing command of the eclectic and the esoteric, something revealed by Gorey's library. Here a vast accumulation of books includes everything from French symbolist poetry, forgotten English novels, and books on Asian ceramics, to ancient issues of *Punch,* odd travel books, turn-of-the-century compendia of parlor games, and at least one volume on napkin folding. Bookshelves line virtually every wall of Gorey's sprawling New England house, a complicated structure repeatedly added on to since about 1800. There is an entire wing whose existence cannot be guessed at from the exterior, although some credit must be given to the rampant vines, exuberant shrubbery, and lush undergrowth of what must have once been an ample side yard. You wouldn't be particularly surprised if one of Gorey's creatures emerged from the underbrush. What is surprising is that the house is not isolated in deep country, where the neglected garden would attract no notice, but occupies a prime location on the green of a small, otherwise rather prim and carefully tended Cape Cod village.

Words and language count a great deal for Gorey. He is a connoisseur of the arcane and the obsolete, but he is equally bemused by more commonplace words whose sounds are pleasurable or peculiar. His tastes are clearly reflected

Opposite: "East Parade, Titipu." Drop curtain for *The Mikado.*
Pages 74–75: Set designs for Acts I and II, *The Mikado.* (Carnegie-Mellon University Drama Department) 1983

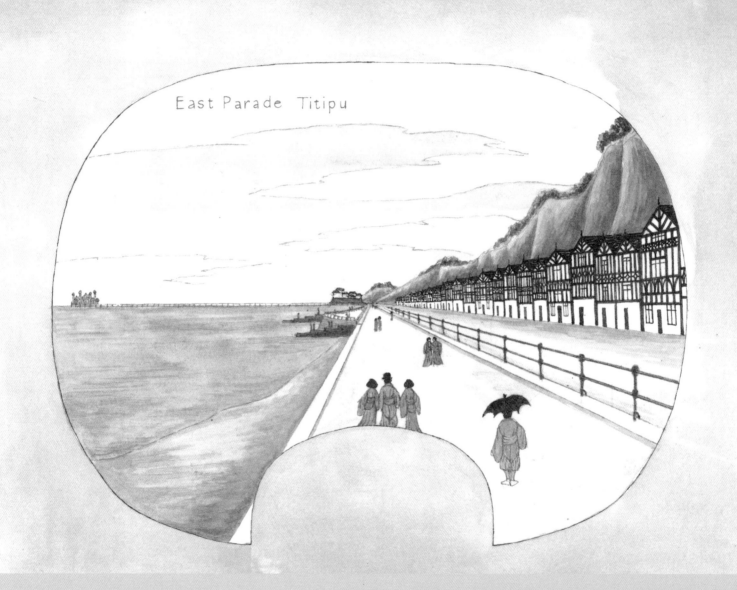

East Parade Titipu

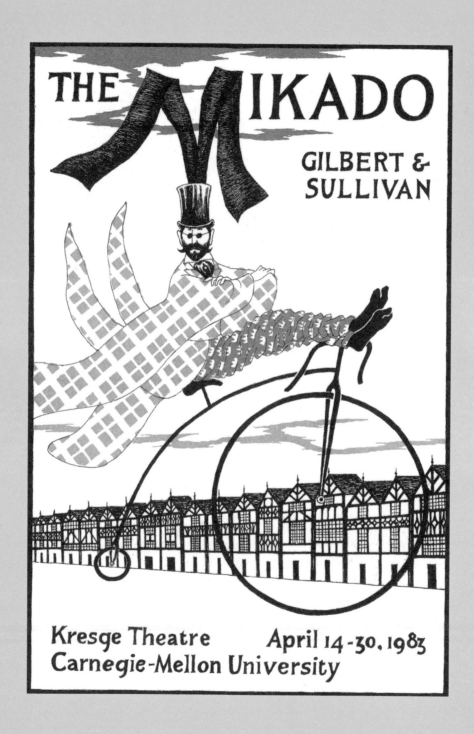

in the names of characters and places in his stories. Jasper Ankle is the obsessed opera lover in *The Blue Aspic*. In *The Remembered Visit*, the family friend who takes Drusilla, aged eleven, to meet "a wonderful old man who had been or done something lofty or cultured in the past," is a Miss Skrim-Pshaw. The travelers in *The Willowdale Handcar* visit Gristleburg and Penetralia. The spirit is Dickensian, and, on occasion, Gorey even seems to pay direct homage to the Victorian master. In *The Gilded Bat*, Maudie Splaytoes, later known as the acclaimed ballerina Mirella Splatova, may have been christened by Gorey because of her ability to achieve perfect turnout, but her name also recalls the Spottletoe family who make a brief appearance in *Martin Chuzzlewit*.

Some of Gorey's books are pure celebrations of the English language. In *The Nursery Frieze*, a delectable parade of hippopotamuses—or are they tapirs—marches against a landscape where the time of day changes, each pronouncing a single, magical word: amaranth, pantechnicon, febrifuge, dismemberment, thurible. *The Glorious Nosebleed* is an alphabet of adverbs with graphic illustrations of such unforgettable, sometimes punning actions as "He fell off the pier Inadvertently," "They searched the cellars Fruitlessly," "She toyed with her beads Jadedly," and—possibly an act of desperation—"The piece was sung eXcrutiatingly." Some of these books are credited not to Edward Gorey, but to a string of alter egos who include, among others, Ogdred Weary, Mrs. Regera Dowdy, Raddory Gewe, and Dreary Wodge, all anagrams of Gorey's name.

He has equal fun in French and Italian, inventing curious but plausible names for ballets, operas, arias, impresarios, and performers. In *The Blue Aspic*, the diva Ortenzia Caviglia (the surname translates as "ankle," like the name of her passionate admirer) has a manager called Ambrogio Rigaglie—Ambrose Giblets. Caviglia's greatest triumphs include her rendition of the aria "Ah, paese dei bovini hispidi!" ("Ah, land of hairy cattle!") from an opera set in Scotland, and "Vide le cerceuil, vide mon coeur" ("The coffin is empty and so is my heart") from *La vengeance posthume*.

Opposite: Flyer for *The Mikado*. (Carnegie-Mellon University Drama Department) 1983 Pages 78–79: From *The Gilded Bat*. 1966

"Eventually she was allowed to go up on point."

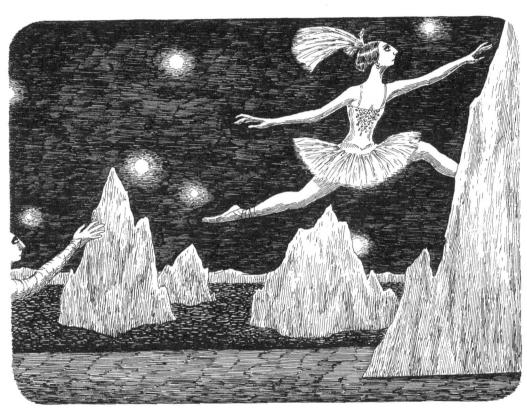

"After Federojenska did a grand jeté."

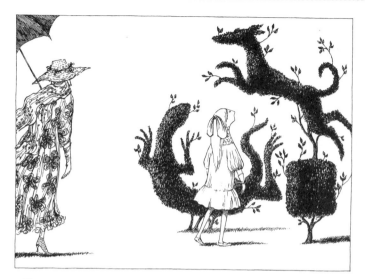

They were shown into a garden where the topiary was being neglected.

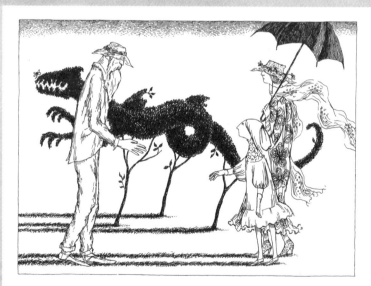

Miss Skrim-Pshaw said it was time they made their adieux.

The complicated relationship of Gorey's work to literary tradition, both high and low, is part of its fascination. The extraordinary depth and breadth of his reading reverberates through his books, echoes of everything from the robust humor and incipient sentimentality of Charles Dickens to the aestheticism and incipient preciousness of Ronald Firbank, the social comedy of Henry Green and Ivy Compton Burnett, and the mordant wit of Oscar Wilde, not to mention a host of Japanese writers, the scripts of old movies, opera libretti, forgotten Victorian novelists, and more. Conventions are followed and skewered, traditions evoked and sneered at, writing styles emulated and parodied, sometimes all at the same time. Impressive and entertaining as Gorey's games with language are, however, it is arguable that the real strength of his work depends on his art. Even the most ordinary of Gorey's drawings repay attention, not only because they expand and embellish his pared-down texts, through their vivid characterizations and absorbing details, but because of their marvelous variety of marks and tones, and often, their unexpected compositions. *What* is depicted is always engaging; *how* it is depicted is always inventive.

The best of Gorey's drawings are equally wonderful for their graphic qualities and the provocativeness of their imagery. They are often models of economy, despite their elaborate graphic devices, composed of a few isolated figures against backgrounds reduced to essentials. Specifics of place are often indicated by fragments cropped by the edge of the drawing—the base of a lamp post, a section of railing, the plinth of a statue visible only from the ankles down—which opens up the confining space of the repetitive formats. Depth is suggested by abrupt, almost Mannerist shifts in scale; a tiny steeple or a gabled rooftop emerging from a screen of ambiguous, hatched shapes immediately turns them into distant treetops and creates a deep space behind the figures who loom in the foreground. It is curious that in spite of his enormous interest in movies, Gorey's compositions are rarely cinematic. More typically, he presents his figures full length, at a constant distance, like actors on a stage, performing within the regular, repeated dimensions of his drawings, so that when he shifts his viewpoint—as he does infrequently—moving in close or backing away, the results are dramatic.

The compelling interiors of Gorey's masterpiece, *The West Wing*, for example, exist autonomously: there is no text. They owe their power to the compressed viewpoints. The spectator is kept off balance, thrust into corners or against walls, confronted with spaces where the usual laws of physics do not seem to apply. Spaces open out of spaces at the same time that the drawings remain declaratively flat. The images of *The West Wing* are notable, as well, for their sumptuous range of tonalities and textures, from wood grain and wallpaper to sea and rock, all articulated with Gorey's usual

Opposite: From *The Remembered Visit: a Story Taken from Life.* 1965

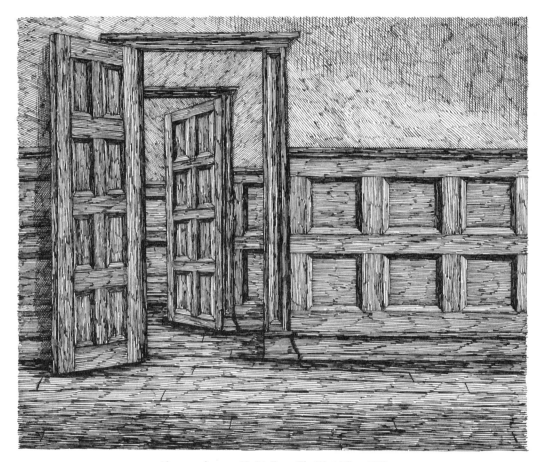

Above and pages 83–84: From *The West Wing*. 1963

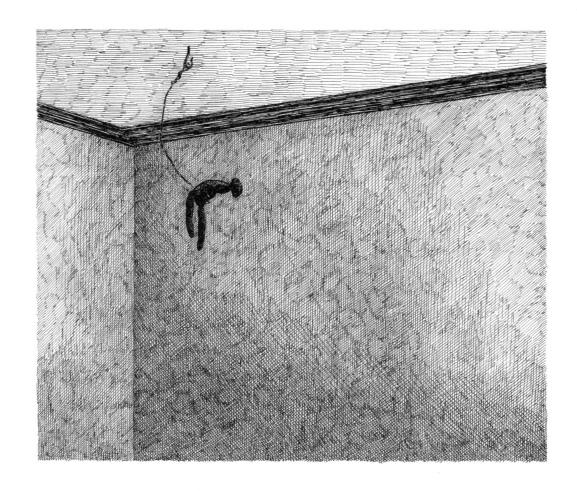

bravura repetitions of line. In some of his works of the 1970s and 80s, such as *The Loathsome Couple,* specific images all but disappear into all-over webs of ink lines and patterns, as though Gorey were testing the limits of drawing conventions, perhaps even the limits of the visible. At times, the narrative provides logical justification for these insistently woven together, detail-blurring accumulations of strokes—scenes in rain, or at night, or in a darkened movie house, where both the audience and the flickering image on the screen are visible—but more frequently, it is evident that the almost pointillist quality of the drawing is a deliberate aesthetic choice.

While Gorey's images can be satisfying on their own, within the context of his books (whether they have texts or not) the drawings function as important carriers of narrative. In the wordless *West Wing,* a kind of plot, or at least a sequence of moods, is suggested only by what happens—or fails to happen—in the series of strange interiors, while in *The Untitled Book,* arguably another of Gorey's masterpieces, text is kept to an absolute minimum of one word per page while

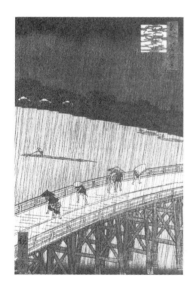

Ando Hiroshige. *A Sudden Shower at Ohashi.* c. 1856

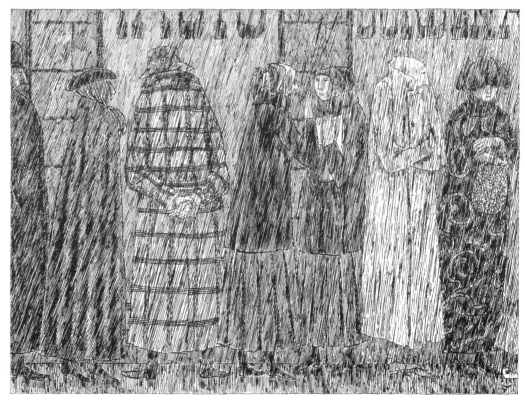

From *The Blue Aspic.* 1968.
"Jasper stood all night in a freezing rain."

85

the action is entirely "recounted" in pictures. The setting in *The Untitled Book* never changes; each picture takes place in an enclosed yard overlooked by a window, a kind of empty box, like a stage. A child looks out of the window, watching a succession of creatures, some nameable, some not, who enter one by one and frolic. The weather changes. A sort of meteor strikes, disrupting the revels. The creatures recover and depart, one by one, leaving the child to stare at the empty yard. Each scene is accompanied by a nonsense word—"oxyboric," "thoo," "ipsifendus"—that seems to encapsulate the action and combines with the others to make a nonsense poem. The pleasure of the book comes from observing the differences between each of the creatures, the variations in what each of them does in each image, the child's changing reactions, and—subtlest, but perhaps most important—the shifts in light and mood conjured up by Gorey's shifts in the density of his hatchings and the saturation of his blacks and whites.

The stage analogy is not accidental, but it is probably dance, specifically the ballet and more specifically, the New York City Ballet, rather than the theater, that has had the strongest effect on Gorey. For the thirty years he lived in New York, from 1953 to 1983, he rarely missed a performance of the New York City Ballet, a conspicuous presence with his beard, fur coat, scarf, and basketball sneakers. (Gorey claims that his leaving New York to live permanently on Cape Cod was spurred by George Balanchine's death in 1983, a decision that has been termed an act of aestheticism worthy of Oscar Wilde.) Gorey's knowledge and understanding of Balanchine's choreography is profound, although he now complains that after so many years' absence from performances he can no longer call up accurate images of movement when he listens to the music of particular ballets. He speaks of Balanchine as having been an enormous influence on him. In part, this could simply be a function of Gorey's ability to recognize excellence, whatever form it may take, but there may also be subtle connections between Gorey's work and his extensive experience of Balanchine's ballets. Balanchine demanded of his dancers erect carriage, a tight fifth position, and absolute clarity of articulation from this neutral, but alert starting point, so that each step and gesture became a precisely aimed, ideally clean thrust into space from a taut center. He was famous for denying that there was anything original in his ideas, claiming that they were merely the essence of the classic Russian ballet: "Is not my technique. Is Petipa's technique," he would say, but his approach not only gave classical movements astonishing clarity and dynamism, but made each deviation from classical movements particularly eloquent. (The speed and musicality he demanded from his dancers were his own.) It is possible that the taut economies of Gorey's compositions, the expressive gestures of his figures, and his way of arranging them within the confines of the defining

Opposite: From *The Loathsome Couple*. 1977.

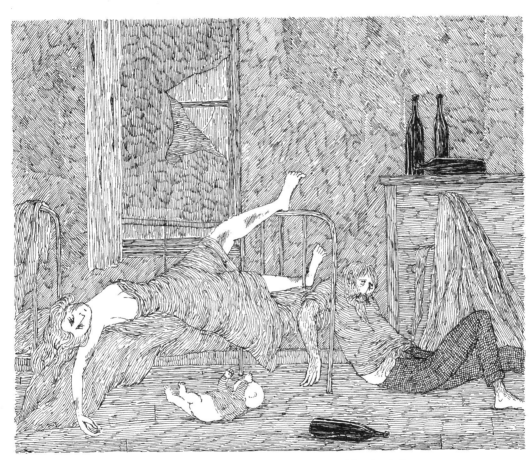

"That year Mona Gritch was born to a pair of drunkards."

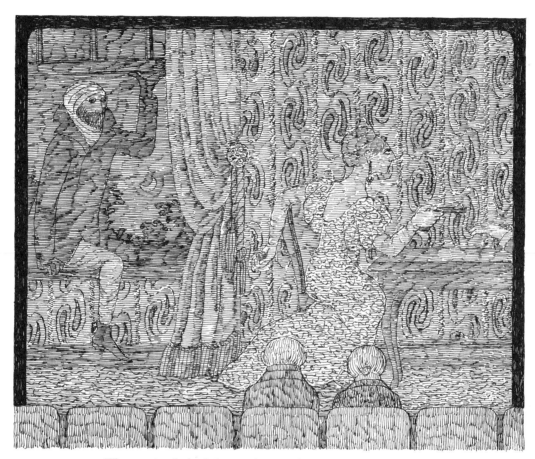

"They went to the local cinema whenever there was a crime film playing."

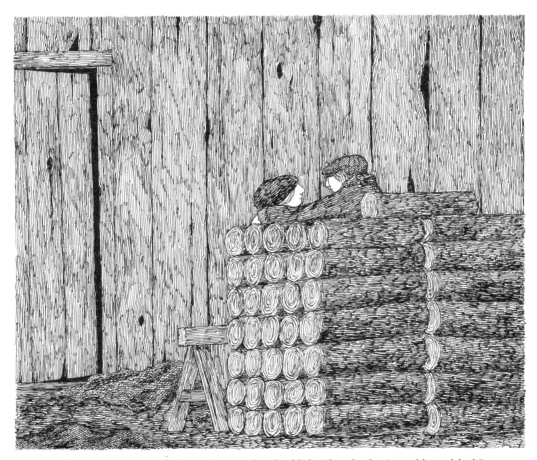

"Following one particularly exciting one, they fumbled with each other in a cold woodshed."

rectangles of his drawings owe something to Balanchine's example. There are, of course, more direct connections, in Gorey's affectionate images of dancers, both on stage and off, in books such as *The Gilded Bat,* the chronicle of a fictitious ballerina, or the extended in-joke, *The Lavender Leotard: or, Going a Lot to the New York City Ballet,* an admittedly esoteric collection of one-liners inspired by the company's repertory, but a joy to anyone who recognizes the references.

Recognizing the references, whether literary or visual, high-minded or popular, is not essential to enjoying Gorey's work, but it can enhance the pleasure his books offer and in no way diminishes appreciation of his originality. On the contrary, it heightens your sense of his ability to transform the known into the remarkable, to make something personal and fresh out of the familiar. Gorey's literary allusions are usually indirect or general—flirtations with particular genres or nods at recognizable conventions, rather than precise allusions to specific antecedents. While it is clear that he is thoroughly at home with a whole range of traditions and draws upon them freely, it is nonetheless impossible to make a precise comparison between a particular Gorey plot and, for example, that of a particular Ivy Compton Burnett novel, however much the tone and flavor of some Goreys and some Burnetts correspond.

The relationship of Gorey's images to other art is no less subtle, but often more direct. His drawings often seem to have the same relation to earlier art that his texts do to earlier writings; the images remind you generally of Edwardian photographs or nineteenth-century illustrations or turn-of-the-century paintings without looking like any specific work. While it is possible, for example, to find a general parallel between the clearly bounded, flat, interlocking shapes and eccentric combinations of patterns with which Gorey habitually constructs his images and the work of Henri Matisse, a painter whom Gorey admires greatly, there is no link to any one Matisse painting. Similarly, while one of the drawings of the sordid underworld of *The Hapless Child* has distinct overtones of Pablo Picasso's Blue Period paintings of the poor and desperate, as well as of Edgar Degas's earlier images of demoralized absinthe drinkers, and of Balthus's paintings, in general there is no specific reference. Gorey's drawings often provoke a nagging sense of previous acquaintance, but they are entirely his own.

Gorey's dialogue with other art, like his dialogue with literary traditions, is simply evidence of his wide-ranging

Above: Katsushika Hokusai. *The Great Wave Off Kanagawa.* c. 1831

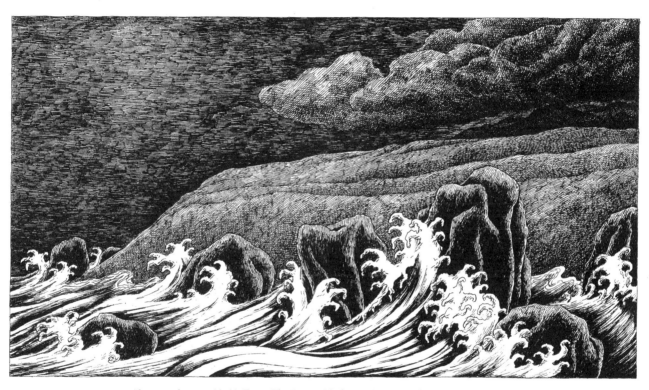

Above and pages 92–93: From *The Dong with the Luminous Nose* by Edward Lear. 1969

knowledge and sophisticated grasp of the discipline. As he does with literature, he wears his visual erudition lightly, never taking it or himself too seriously. Just as he can dissect or assemble literary genres, he can twist art historical precedents for his own ends. In *The Broken Spoke,* he traces a supposed history of cycling from prehistory to the vaguely nineteenth-century present, offering as evidence images of bicycles from cave painting, eleventh-century English pen-style manuscript illumination, American folk art, Aubrey Beardsley, and a little German Expressionism, along with "typical" Gorey images. The point, of course, is the transformation of allusions—the shock of finding cyclists depicted on a rock wall with a trumpeting mammoth, but even in less parodic works in which Gorey is overt about his sources, he never follows them slavishly. Some of his illustrations for a retelling of the Brer Rabbit stories are obviously indebted to the silhouettes and stylizations of fraktur drawings and Pennsylvania Dutch folk art, but other images in the series seem to be purely the products of Gorey's imagination, perhaps with an admixture of Japanese prints.

Yet some of the most seductive, accomplished, and often beautiful of Gorey's drawings have undisguised origins in other works of art, sources that he either consciously or unconsciously exploits for their associative power. (This is not the cynical, rather random "appropriation" of imagery so fashionable among certain younger artists.) Gorey's sources can appear to have been selected to reinforce the mood of words and pictures, or they can seem completely unrelated, as though chosen to provide invigorating contrast. In his drawings for Lear's *The Jumblies* and *The Dong with the Luminous Nose,* Gorey invented a mysterious Northern seaside country, a kind of fantastic Scotland, complete with "hairy cattle," forests of trees with slender trunks, crenellated stone buildings, and long stretches of beach. The scenes of the Jumblies in their seagoing sieve are among Gorey's most intricate and engaging; the forest scenes, with the rays of the Dong's nose shining among the trees, are some of his most lyrical, poetic images. The sea that laps at the coast of this imaginary land, however, is borrowed frankly from *The Great Wave Off Kanagawa,* the iconic print by the Japanese woodblock master Hokusai. The jolt of finding a Japanese seascape, with its stylized, curling foam and its dramatic contrasts of dark and light embedded in the otherwise wholly Western, Anglophile context of Gorey's images and Lear's Victorian nonsense verse is considerable. But somehow, Hokusai's wave makes Gorey's scurrying figures more convincing, rather in the way that the fragments of actuality—the newspapers and pages of sheet music—that the Cubists collaged into their pictures turned the drawn and painted elements of their pictures into the norm and cast the pasted papers into the role of foreign emissaries from another existence.

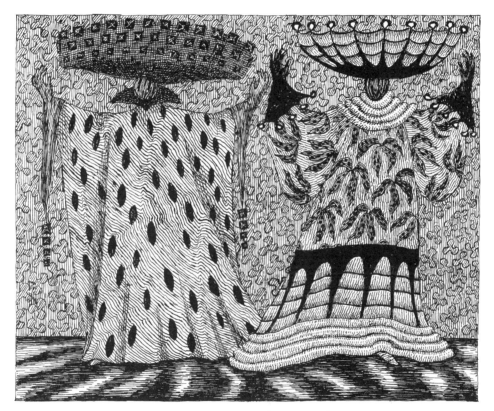

Above and overleaf: From *The Prune People*. 1983

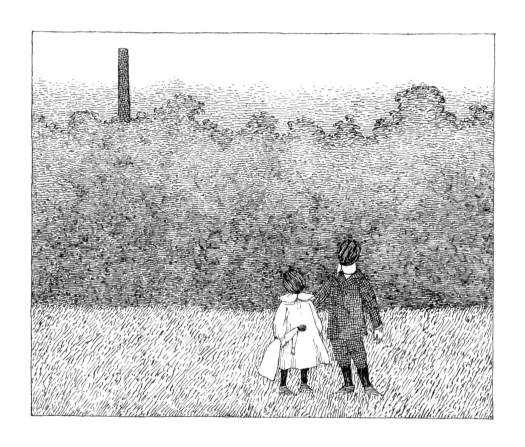

Not surprisingly, given the disquieting atmosphere of the majority of Gorey's works, many of his closest links are with the Surrealists or with artists "claimed" by the Surrealists as forebears. René Magritte's paintings are often invoked, but not imitated, by Gorey's drawings, particularly those without accompanying words. The ambiguous interiors of *The West Wing*, with their ominous, over-scaled cracks, their inexplicable shifts from interior to exterior, and their ordinary objects wrenched out of context, altered in scale, and released from normal physical laws, read like tributes to the Belgian artist, but in other works, Gorey seems to parody as much as to praise. The faceless personages of *The Prune People*, for example, could be descendants of Magritte's famous masked lovers, with their faces covered in cloth, but Gorey's characters could equally well trace their lineage to the crudest of rag dolls.

Gorey's references can be both obvious and throwaway. In *The Object Lesson*, one of his most unnerving, "surrealizing" tales, both in text and imagery, a bearded man wearing a fur coat, striped pajama bottoms, and slippers, sits at the base of a statue of Corrupted Endeavor, "to await the arrival of autumn." The statue is a rapid, schematized allusion to the reclining figure than recurs in many of Giorgio De Chirico's mournful paintings of twilit piazzas, and the association intensifies the mood of strangeness and absence that pervades Gorey's drawing. Similarly rapid references to well-known compositions by Balthus, with their oddly stiff, but vulnerable adolescents who seem violated by the artist's gaze, permeate many of Gorey's works, while elements of the seemingly straightforward landscapes of *The Iron Tonic* frequently appear to have sprung from the same nightmares as the so-called *noirs* of Odilon Redon—those weird dream images of floating eyeballs, menacing heads, and hybrid plant-men, cited by the Surrealists, like De Chirico's melancholy cityscapes, as prototypes for their own efforts to depict the "interior landscape" of the subconscious.

Often, it seems as though Gorey had no particular source in mind, but simply filtered a conception through his prodigious memory of other images or leaned on a remembered notion that vibrated sympathetically with his ideas. How else to explain the odd connection between one of Gorey's drawings for *The Blue Aspic* and Paul Klee's early etching, *Virgin in a Tree*? The subjects are nominally different and in Gorey's image of the deranged opera buff, Jasper Ankle,

Above: René Magritte. *Les Amants (The Lovers)*. 1928

escaping from the asylum to which he was committed, dropping his precious records, the figure is male, clad in a long, striped nightshirt, and arranged in a pose only tenuously related to that of Klee's painfully thin female nude. Yet there is something about the slender tree that Jasper climbs and the general wiriness of Gorey's drawing that immediately brings Klee's etching (itself derived from a Renaissance print) to mind. The strongest connection may be a purely formal one, in the way the two figures occupy the space of their respective compositions—each is placed high up and stretched horizontally across the page—but the similarity of mood is also notable.

Gorey is frank about his debt to Max Ernst, claiming that he might not have conceived one of his most celebrated creatures, the long-armed, frog-teddy bear-*something* hybrid known as "Figbash," without Ernst's prototype. The affinity between Gorey's art and Ernst's can be surprisingly deep. The very textures of Gorey's obsessive crosshatchings evoke Ernst's frottages—rubbings made from ordinary surfaces, such as floorboards and tabletops, transformed both by virtue of having been selected by the artist and by the action of his hand. Ernst's frequent recourse to old engravings and illustrations from the era before photography as the basis for his improvisations also appears to strike sympathetic chords in Gorey. There are echos of Ernst's creepy interiors and threatening forests in many of Gorey's works, probably indirect ones, as is most often the case with such connections, but there is an overt acknowledgment of Ernst's influence in at least one of Gorey's most inventive books, the participatory fantasy *The Raging Tide: or, the Black Doll's Imbroglio.*

The plot, such as it is, of *The Raging Tide* advances (and retreats) in fits and starts, as befits the title. Gorey invites the reader to follow alternative sequences instead of proceeding from page to page in the usual order. When the characters—unreal, toylike creatures who include a battered bear with a kind of lampshade on his head and Figbash— resolve, on page twenty-three, to visit a local attraction, the text reads: "It is open to the public only one Tuesday a month. If you want to hark back to the story, turn to page 17. For a stunning irrelevancy, turn to 15." But no matter what path you

Above: Giorgio De Chirico. *The Soothsayer's Recompense.* 1913

Above and pages 99, 100–101: From *The Object Lesson.* 1958

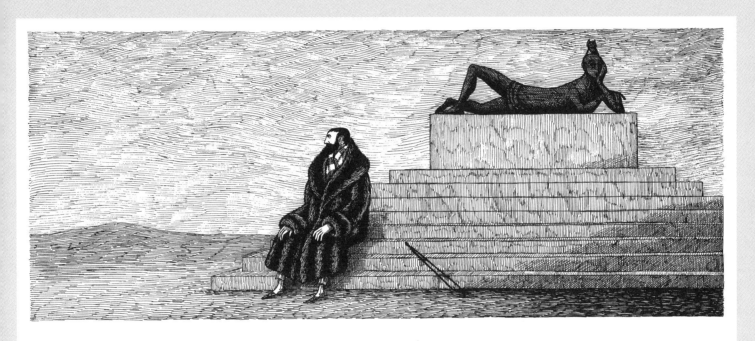

to await the arrival of autumn.

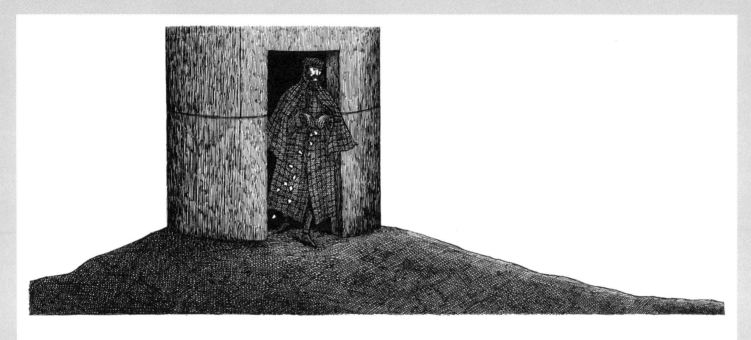

He descended, destroying the letter unread,

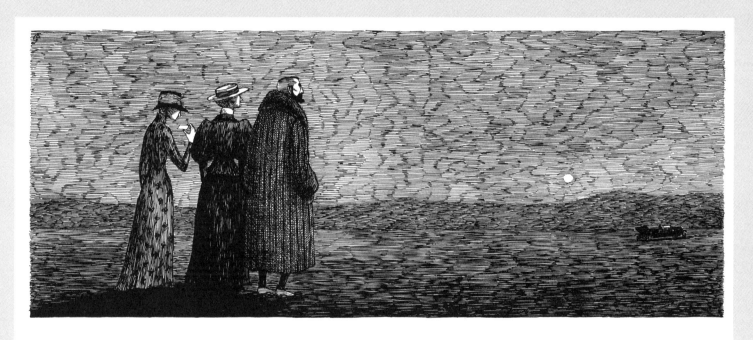

Farewell.

choose, you will be sent backward and forward through the text, following a logical thread that becomes increasingly irrelevant.

The drawings are among Gorey's finest, with a particularly rich orchestration of tonalities and a subtle spectrum of patterns and marks. They are as disorienting as the many-layered text, but utterly charming. Gorey emphasizes the off-balance effect of the multidirectional text by playing a space within a space in one image. In others, the animated, not-quite describable protagonists squabble like peevish children against moody backgrounds. A sort of giant thumb-plinth-statue, which recurs in various guises, owes a great deal to one of Ernst's better known images from the 1920s, a painting in which oversized fingers reach out of a window to grasp a nameless composite object. But Ernst's immense thumb and forefinger are agonizingly pierced, while Gorey's bent thumb-statue, although detached from the gargantuan hand to which it must belong, has no associations of mutilation or pain.

Instead, its sheer hugeness seems comical and harmless, perhaps because it is isolated from the rest of the body. It has associations, too, with the monumental fragments, shattered remains of immense portraits of the emperors of Rome's declining years, that turn up in unlikely places in the center of the modern city. (The best known is probably the enormous sandaled foot installed on a handsome base at the start of Via Pie' di Marmo, "marble foot street.") In one of Gorey's prints, a cat, paws tucked neatly in, perches happily on the end of the gigantic digit.

In the end, of course, these allusions and connections, provocative as they may be, are only one ingredient in the inspired mix of Gorey's art and writings. While it is obvious that a lifetime of omnivorous reading and passionate looking informs every aspect of his work, references to antecedents, whatever their origins, function like complex seasonings in the cooking of a brilliant chef; they may be essential to the result, but they are interesting only because they amalgamate to make something completely new and distinctive. Knowing the details of Gorey's sources—the catalogue of his spices and herbs—tells you little about what makes his magical books so compelling. At best, it simply reminds you of what an

Opposite: From *The Blue Aspic*. 1968
Above: Paul Klee. *Virgin in a Tree (Invention 3)*. 1903

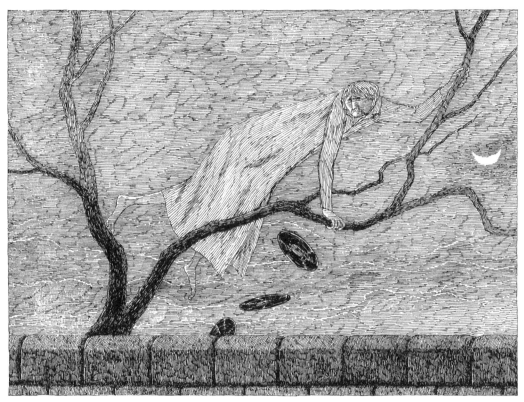

"Jasper's records got broken as he was escaping from the asylum."

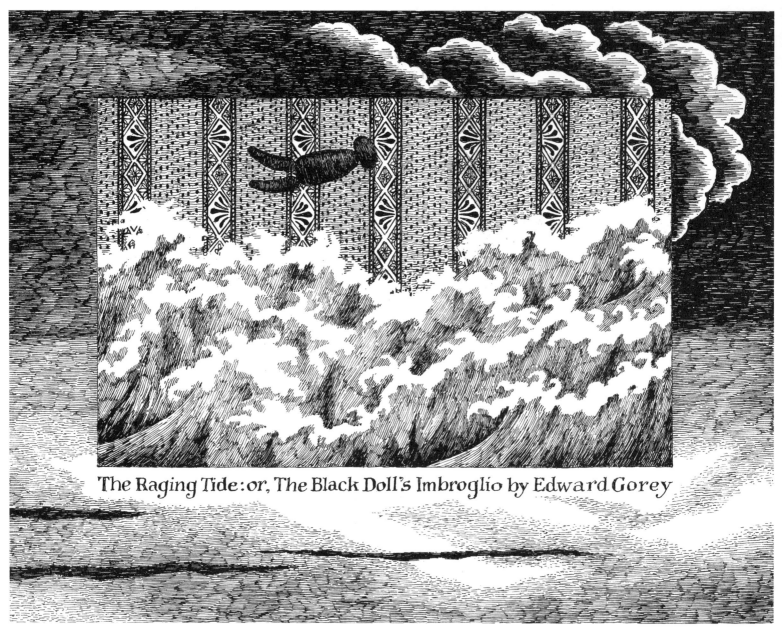

The Raging Tide: or, The Black Doll's Imbroglio by Edward Gorey

Cover for *The Raging Tide: or, the Black Doll's Imbroglio.* 1987

Pages 105–107: From *The Raging Tide: or, the Black Doll's Imbroglio.* 1987

Figbash threw an antimacassar over Skrump.

Figbash and Hooglyboo and Naeelah forgave each other
over boiled turnips.

It is open to the public only one Tuesday a month.

extremely fascinating, multitalented individual their creator is, something that is hardly news to any Gorey fan, whether that fan is a long-standing devotée or a recent convert.

Gorey's images and texts are mysterious. He cultivates ellipsis to great effect, but there is one completely inexplicable anomaly in his work as a whole. His books seem equally driven by word and image, with images dominating completely or almost completely in several volumes. His ventures into other disciplines have been almost entirely in the realm of the visual—as set designer, illustrator, graphic artist, costume designer, typographer, and the like; he has exhibited a series of drawings that pre-date *The Unstrung Harp* and he continues to make prints from time to time that are independent of any narrative text. Yet when Gorey portrays himself or creates a Gorey-surrogate in his books, he always presents himself as a writer. The bearded, fur-swathed, sneaker-shod figure who links the various images of one of the versions of the alphabet rhyme, *The Chinese Obelisks,* is described at the beginning as "an author who went for a walk." He

E an Egyptian with things from a tomb From *The Chinese Obelisks.*
(Sketch version). 1975

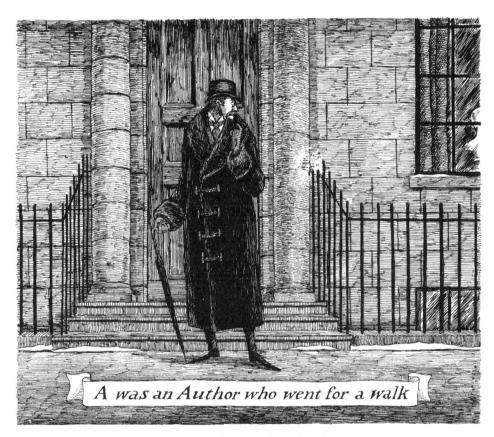

A was an Author who went for a walk

Unused variant from *The Chinese Obelisks*. 1970

They searched the cellars Fruitlessly.

turns up again, a little older, now wearing glasses, at the end of *The Glorious Nosebleed*, notepad in hand, as the person who "wrote it all down Zealously." In Gorey's first book, Mr. Earbrass, a Gorey-esque figure, allowing for a certain license, is seen thinking about writing, actually writing, searching for a citation, editing galleys—in short, going about all the ordinary activities of a working writer. There is no equivalent Gorey-artist figure.

Opposite and right:
From *The Glorious Nosebleed*. 1974

He wrote it all down Zealously.

Yet the words in the books composed by "the author who went for a walk" and "wrote it all down Zealously" are not only intimately connected to his full-blown, elegant drawings, but are always subservient to his images. Pictures are probably more crucial than words to our sense of what Gorey is about. Important as his love of language, his carefully shaped sentences, and his tight rhymes may be to the character of his entrancing books, it is Gorey's imagery that etches itself in the memory, like an album of fading photographs from a vanished era, a series of isolated moments from a world at once unsettling, even baffling, but at the same time immensely appealing and wholly convincing.

The Plates

From *A Sinister Alphabet*. (Unpublished). August 27, 1955

Opposite: Sketch and cover for *The Gorey Alphabet*. 1961

THE GOREY ALPHABET

EDWARD GOREY

Sketch for *The Jumblies* by Edward Lear. 1968

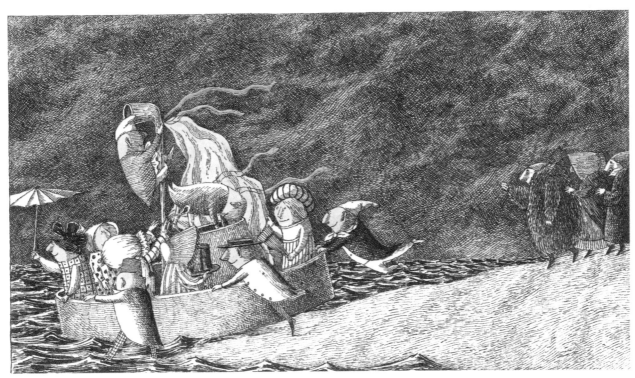

Study for *The Jumblies* by Edward Lear. 1968

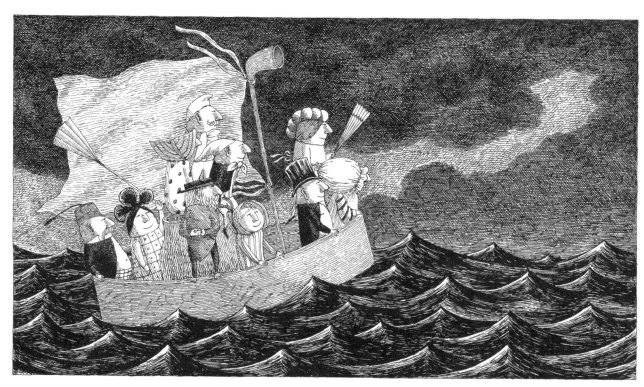

Above and pages 119–21: From *The Jumblies* by Edward Lear. 1968

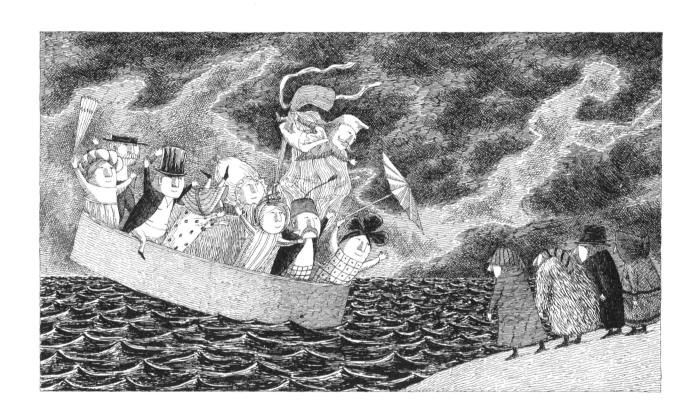

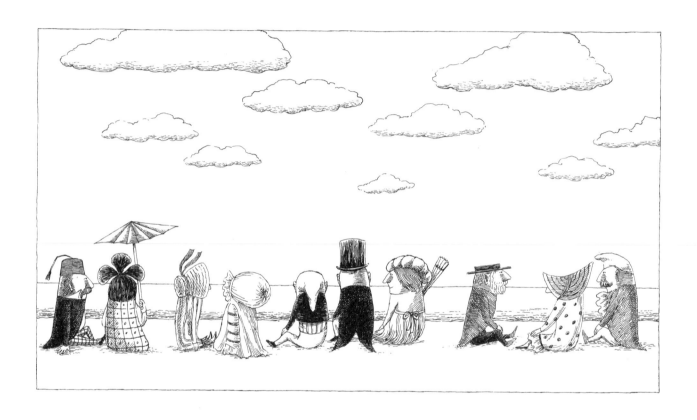

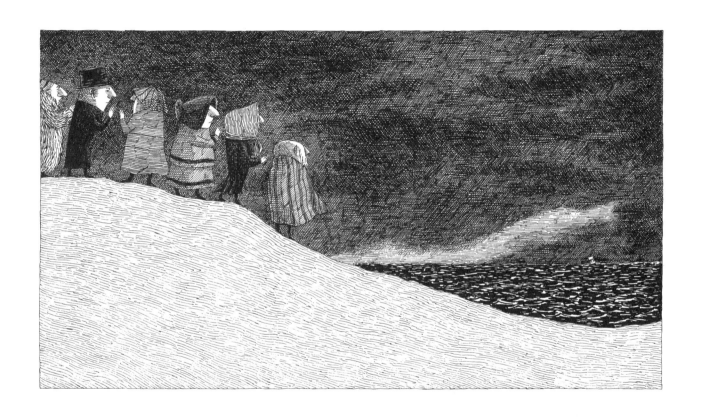

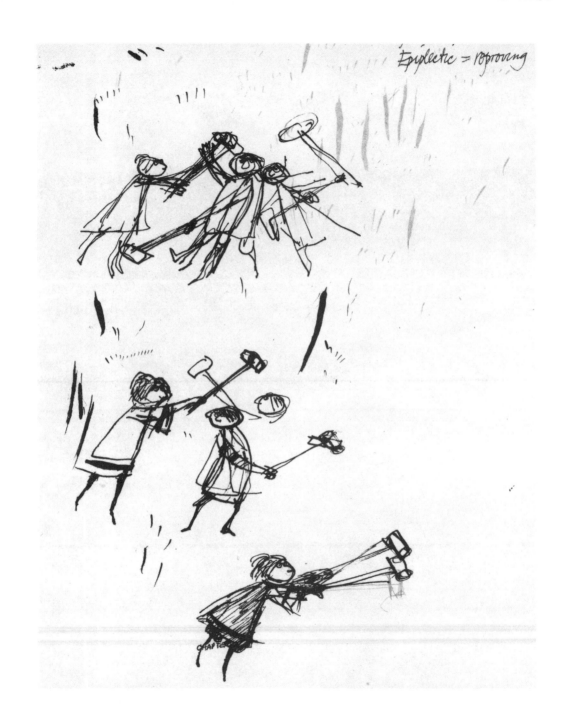

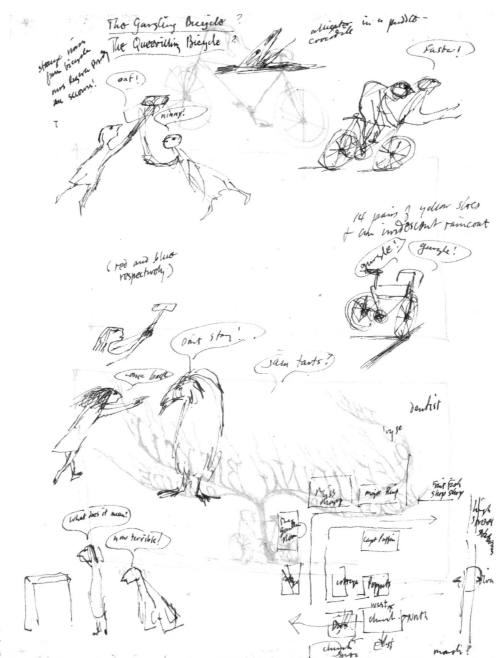

Opposite and right:
Sketches and notes for
The Epiplectic Bicycle. 1969

Pages 124–125: From *The Epiplectic Bicycle*. 1969

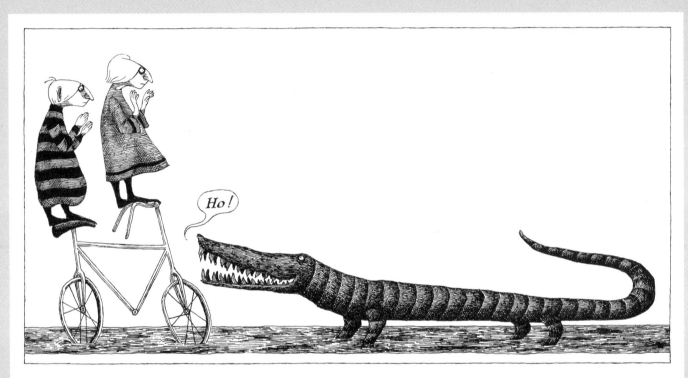

an alligator rose up in front of them;

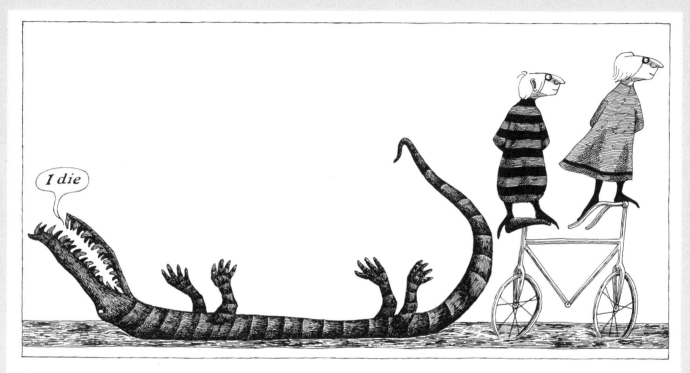

Embley kicked it on the end of its nose, and it expired.

He was interred; the bird alone
Was left to sit upon his stone.

Above and right: From *The Osbick Bird*. 1970

But after several months, one day
It changed its mind and flew away.

Opposite: From *The Eleventh Episode*. 1971

Her laugh made beetles swoon; her frown
Made geese and cows turn upside down.

They dazzle us, but can we trust
These pictures drawn upon the dust?

THE IPSIAD, *can. V*

From *The Awdrey-Gore Legacy*. 1972

Cover for *The Awdrey-Gore Legacy*. 1972

Above and opposite: From *The Awdrey-Gore Legacy.* 1972

Unsuccessful escape

SHARP

dagger hat pins

He was, it's said, somehow done in
With nothing but a safety pin.

THE IPSIAD, *can. VI*

Above and pages 133–35: From *The Awdrey-Gore Legacy*. 1972. "Weapons."

GRADUAL

arsenical buns

INSTANTANEOUS

boulder

INEXPLICABLE

confetti

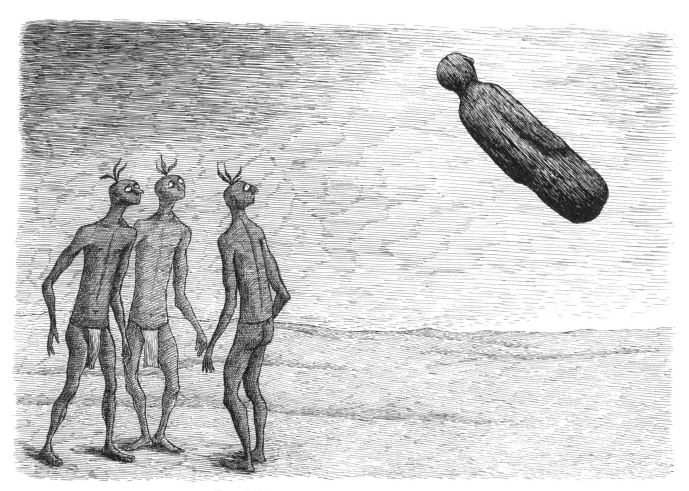

From *A Sinister Alphabet*. (Unpublished). August 18, 1955

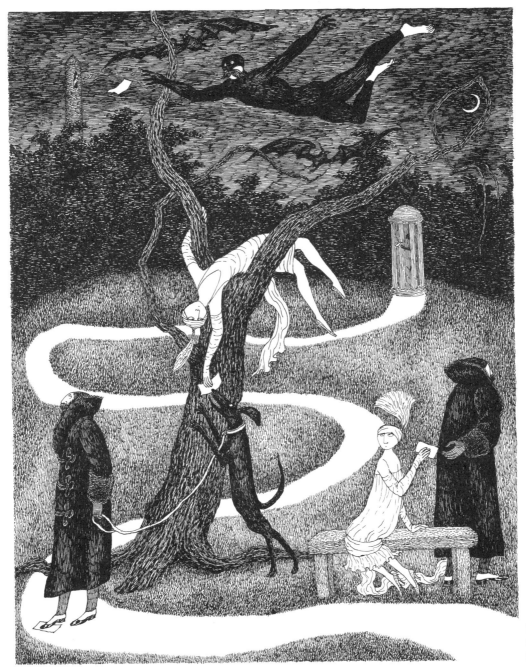

Untitled drawing
related to *Other People's
Mail.* n.d.

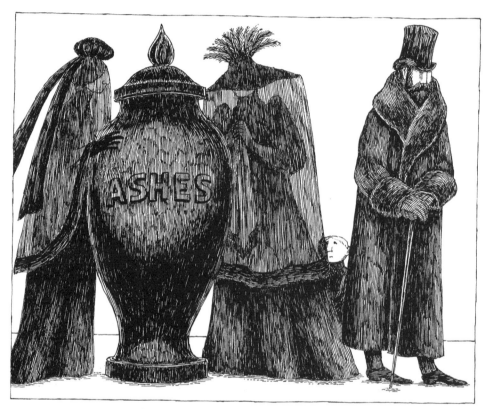

Above and opposite: From *Les Urnes Utiles*. 1980

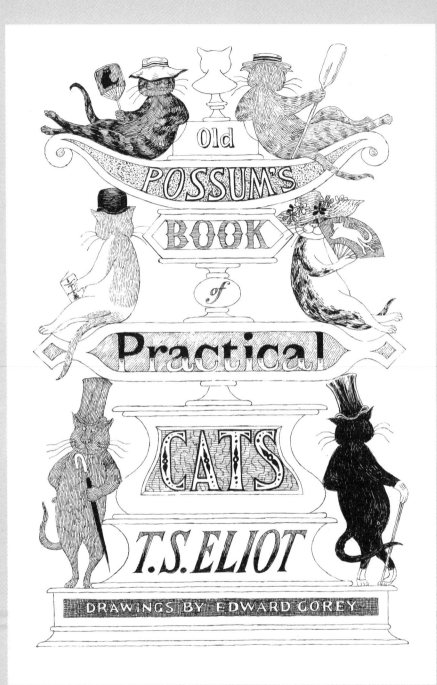

"Gus the Theatre Cat."

"Growltiger."

Opposite and above: Cover and pages for *Old Possum's Book of Practical Cats* by T. S. Eliot. 1982

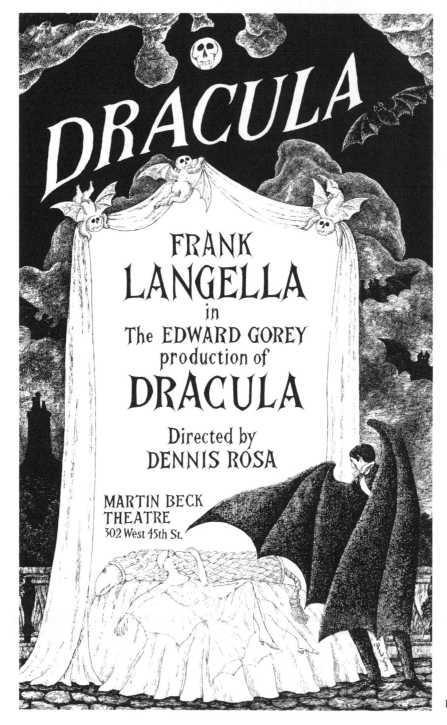

Poster for *Dracula.* 1977

"A Dream of Dracula."
For *The New York Times
Book Review*. 1973

Left and
pages 145–47:
From *Dracula,*
A Toy Theater. 1979

Above and opposite: Front and back covers for Edward Gorey's *Dracula* (unpublished).

EDWARD GOREY'S DRACULA

"Grand Curtain" for *Dracula*, Martin Beck Theatre, 1977

Drop curtain for *Amphigorey*. n.d.

T-shirt design for the Metropolitan Opera. n.d.

Drawing for a book by Craig Claiborne. n.d.

153

CAUTIONARY TALES FOR CHILDREN

HILAIRE BELLOC

DRAWINGS BY EDWARD GOREY

CAUTIONARY TALES FOR CHILDREN

HILAIRE BELLOC

DRAWINGS BY EDWARD GOREY

Cover for *Cautionary Tales for Children* by Hilaire Belloc. (Unpublished)

In Central Park appearance of the first daffodil coincides with deepest snow of year

Disappearance of all spring and summer garments from the stores

"Signs of Spring." 1988

In SoHo lofts undreamt extensions of the frontiers of the Dance

Pedestrian peril in the Relentless Reaches of the Upper East and West Sides

75¢
In Canada
90¢

LAFCADIO'S ADVENTURES

A NOVEL BY
ANDRÉ GIDE
Awarded the Nobel Prize
for Literature

ANCHOR
A 6

ANCHOR
A 6

A DOUBLEDAY ANCHOR BOOK

LAFCADIO'S ADVENTURES ANDRÉ GIDE

Cover for *Tales of Good and Evil*
by Nicolai V. Gogol. 1957

Opposite: Cover for *Lafcadio's Adventures* by André Gide. 1953

Drawing for record jacket cover. January 2–February 3, 1976

Cover for *The Gilded Bat.* 1966

Cover for *The Broken Spoke*. 1976

THE BROKEN SPOKE / EDWARD GOREY

Above and opposite: Based on the *Mystery!* television series, drawings for the edge of a note cube. 1988

MYSTERY!

Above and detail opposite: Poster for *Mystery!* television series

Left and opposite:
Drawings for front
and back covers for
Amphigorey Too. 1975

Innocence, on the Bicycle of Propriety, carrying the Urn of Reputation safely over the Abyss of Indiscretion

From *The Broken Spoke*. 1976

Opposite: Dedication page from *The Dong with the Luminous Nose*. 1969

The drawings are for Livia, Agrippina, and Kanzuke

From *Brer Rabbit and His Tricks* by Ennis Reese. 1967. "Brer Rabbit and the Tar Baby."

From *QRV*. (Miniature). 1989

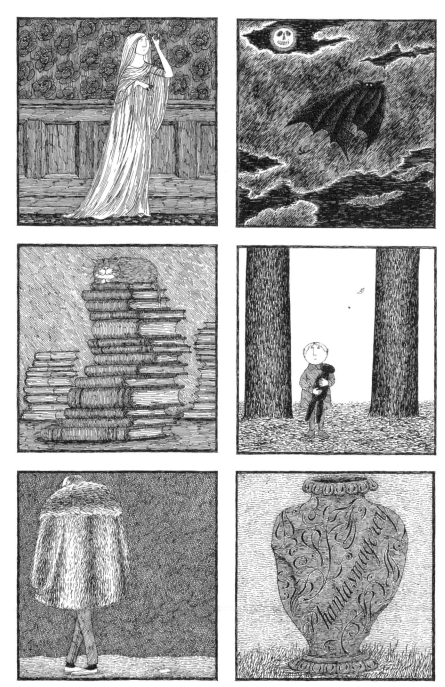

Cover design for
Phantasmagorey. 1974

List of Plates

All works are by Edward Gorey and in his collection unless otherwise specified. When images are from books, the date given is the year of publication. Dimensions are of the actual image.

Page 1
Drawing for "The Doubtful Guest" from *Leaves from a Mislaid Album*. 1972. Pen and ink, 4¼ x 2¾"

Pages 3 and 192
From *Les Echanges Malandreaux*. 1985. Pen and ink, 6½ x 6½"

Pages 4, 5, 7, and 41
Drawings for the animated title sequence of *Mystery!* television series. c. 1980. Pen and ink, pencil, watercolor, a–e: 7¼ x 3¾"; f: 3¾ x 7¼"

Pages 6 and 189
Front and back cover designs for *The Gashlycrumb Tinies or, After the Outing*. 1963. Pen and ink, front: 4¾ x 4½"; back: 1¾ x 4¾"

Page 8
From *The Chinese Obelisks*. 1970. Pen and ink, 4 x 5"

Pages 9, 43, 113, 173, and 190–91
From *Figbash Acrobate* (a Figbash alphabet). 1994. Pen and ink

Page 10
From *The Hapless Child*. 1961. Pen and ink, 7¾ x 6⅞"

Pages 12 and 13
Covers for *The Untitled Book*. 1971. Pen and ink, each 5 x 6"

Pages 14 and 15
The Untitled Book. 1971. (Complete.) Pen and ink, each page 5 x 6"

Pages 16 and 17
From *The Hapless Child*. 1961. Pen and ink, 7¾ x 6⅞"

Page 18
From *The Unstrung Harp*. 1953. Pen and ink, 4½ x 3½"

Pages 20 and 21
Five sketches and notes for *The Secrets: Volume One, The Other Statue*. 1968. Pages 2, 3, 20, 21 from an undated notebook. Pen and ink, each sheet 4 x 6"

Page 22
Sketches and notes for "A Peculiar Visitor." c. 1955. Published as *The Doubtful Guest*. 1957. Pen and ink, 5½ x 8½"

Pages 23, 24, and 25
From *The Doubtful Guest*. 1957. Pen and ink, 5 x 7½"

Pages 26 and 27
Prototype front and back covers for "The Visit," published as *The Doubtful Guest*. 1957. Pen and ink and watercolor, 5¼ x 8"

Page 28
Unfinished sketch for *The Blue Aspic*. 1968. Pencil, pen and ink, 4 x 5½"

Pages 30 and 31
Costume designs for *The Mikado*. (Carnegie-Mellon University Drama Department.) a. The Mikado. b. Yum-Yum. c. Katisha. d. Pish-Tush. 1983. Pen and ink, watercolor, each 9 x 11⅜"

Page 32
Sketches for drop curtains for *The Concert*, ballet choreographed by Jerome Robbins. November 1981. Pen and ink, watercolor, each 5½ x 6½"

Pages 34 and 35
Drop curtains for *The Concert*, ballet choreographed by Jerome Robbins. November 14, 1981. Pen and ink, watercolor, each 7⅜ x 12½"

Page 85

From *The Blue Aspic*. 1968. Pen and ink, 4 x 5½"

Page 85

Ando Hiroshige. *A Sudden Shower at Ohashi*. c. 1856. Woodblock print, 13⅜ x 14⅞". The Metropolitan Museum of Art, New York. Purchase Joseph Pulitzer Bequest, 1918

Pages 87, 88, and 89

From *The Loathsome Couple*. 1977. Pen and ink, 4½ x 5¼"

Page 90

Katsushika Hokusai. *The Great Wave Off Kanagawa*. c. 1831. Woodblock print, 10⅛ x 14⅞". The Metropolitan Museum of Art, New York. Henry L. Phillips Collection, Bequest of Henry L. Phillips, 1939

Pages 91, 92, and 93

From *The Dong with the Luminous Nose* by Edward Lear. 1969. Pen and ink, 3¾ x 6¾"

Pages 95 and 96

From *The Prune People*. 1983. Pen and ink, 4 x 5"

Page 97

René Magritte. *Les Amants (The Lovers)*. 1928. Oil on canvas, 21⅛ x 27¾". Australian National Gallery, Canberra

Page 98

Giorgio De Chirico. *The Soothsayer's Recompense*. 1913. Oil on canvas, 53½ x 71". Philadelphia Museum of Art. The Louise and Walter Arensberg Collection

Pages 99, 100, and 101

From *The Object Lesson*. 1958. Pen and ink, 5¾ x 8½"

Page 102

Paul Klee. *Virgin in the Tree (Invention 3)*. 1903. Etching, 9⁵⁄₁₆ x 11¹¹⁄₁₆". Museum of Modern Art, New York. Abby Aldrich Rockefeller Fund

Page 103

From *The Blue Aspic*. 1968. Pen and ink, 4 x 5½"

Page 104

Cover for *The Raging Tide: or, the Black Doll's Imbroglio*. 1987. Pen and ink, 9 x 10½"

Pages 105, 106, and 107

From *The Raging Tide: or, the Black Doll's Imbroglio*. 1987. Pen and ink, 4 x 6½"

Page 108

From *The Chinese Obelisks*. (Sketch version). 1975. Pen and ink, 4½ x 8"

Page 109

Unused variant from *The Chinese Obelisks*. 1970. Pen and ink, 5¾ x 6¼"

Pages 110 and 111

From *The Glorious Nosebleed*. 1974. Pen and ink, 4¼ x 5"

Page 114

From *A Sinister Alphabet*. (Unpublished.) August 27, 1955. Pen and ink, 6½ x 8"

Page 115

Sketch for cover of *The Gorey Alphabet*. 1961. (British edition of *The Fatal Lozenge*. 1960.) Pen and ink, 5½ x 4¼"

Page 115

Cover for *The Gorey Alphabet*. 1961. (British edition of *The Fatal Lozenge*. 1960.) Pen and ink, 6 x 5"

Page 116

Sketch for *The Jumblies* by Edward Lear. 1968. Pen and ink with watercolor, 6 x 8¾"

Page 117

Study for *The Jumblies* by Edward Lear. 1968. Pen and ink with watercolor, 3¾ x 6¾"

Pages 118, 119, 120, and 121

From *The Jumblies* by Edward Lear. 1968. Pen and ink, 3¾ x 6¾"

Pages 122 and 123

Sketches and notes for *The Epiplectic Bicycle*. 1969. Pen and ink, 11 x 8½"

Pages 124 and 125

From *The Epiplectic Bicycle*. 1969. Pen and ink, 7 x 3½"

Pages 124 and 125

From *Dracula, a Toy Theater*. 1979. Four drawings, pen and ink, each 11½ x 7¼"

Page 126

From *The Osbick Bird*. 1970. Pen and ink, 4 x 5"

Page 127
From *The Eleventh Episode*. 1971. Pen and ink, 7½ x 7"

Page 128
From *The Awdrey-Gore Legacy*. 1972. Pen and ink, watercolor, 8 x 11"

Page 129
Cover for *The Awdrey-Gore Legacy*. 1972. Pen and ink, watercolor, 7½ x 12"

Pages 130 and 131
From *The Awdrey-Gore Legacy*. 1972. Pen and ink, 4 x 4½"

Page 132
From *The Awdrey-Gore Legacy*. 1972. "Weapons." Pen and ink, 3½ x 4"

Page 133
From *The Awdrey-Gore Legacy*. 1972. "Weapons." Pen and ink, 3½ x 6¼"

Page 134
From *The Awdrey-Gore Legacy*. 1972. "Weapons." Pen and ink, 3½ x 4¾"

Page 135
From *The Awdrey-Gore Legacy*. 1972. "Weapons." Pen and ink, 5 x 2¾"

Page 136
From *A Sinister Alphabet*. (Unpublished.) August 18, 1955. Pen and ink, 5 x 7½"

Page 137
Untitled drawing related to *Other People's Mail*. n.d. Pen and ink, 10 x 7¾"

Pages 138 and 139
From *Les Urnes Utiles*. 1980. Pen and ink, 4 x 5"

Page 140
Cover for *The Old Possum's Book of Practical Cats* by T. S. Eliot. 1982. Pen and ink, 8 x 5¼"

Page 141
From *The Old Possum's Book of Practical Cats* by T. S. Eliot. 1982. Pen and ink, 6½ x 4½"

Page 142
Poster for *Dracula*. 1977. Pen and ink, 22 x 14". Collection Gotham Book Mart, New York

Page 143
"A Dream of Dracula." For *The New York Times Book Review*. 1973. Pen and ink, wash, 11 x 4½"

Pages 146 and 147
From *Dracula, a Toy Theater*. 1979. Pen and ink, each 8 x 7¾"

Pages 148 and 149
Front and back covers for Edward Gorey's *Dracula* (unpublished). n.d. Front: 8¾ x 11"; back: 8⅜ x 11". Collection Mrs. Frances Massey Dulaney

Page 150
"Grand Curtain" for *Dracula*, Martin Beck Theatre, 1977. Ink and watercolor, 13½ x 19¾". Collection Mrs. Frances Massey Dulaney

Page 151
Drop curtain for *Amphigorey*. Pen and ink, 6¼ x 10". Collection Mrs. Frances Massey Dulaney

Page 152
T-shirt design for the Metropolitan Opera. n.d. Pen and ink, 7¼ x 9½"

Page 153
Drawing for a book by Craig Claiborne. n.d. Pen and ink, 6½ x 11½"

Page 154
Front and back covers for *Cautionary Tales for Children* by Hilaire Belloc. (Unpublished.) Pen and ink, watercolor, 9¾ x 13½"

Page 155
"Signs of Spring." 1988. Pen and ink, watercolor, 12¼ x 9¾"

Page 156
Cover for *Lafcadio's Adventures* by André Gide. 1953. Pen and ink, 7⅝ x 5⅜"

Page 157
Cover for *Tales of Good and Evil* by Nicolai V. Gogol. 1957. Pen and ink, wash, watercolor, 7⅛ x 4⅛"

Page 158
Drawing for record jacket cover. January 2–February 3, 1976. Pen and ink, 12¾ x 12¾"

Page 159
Cover for *The Gilded Bat*. 1966. Pen, brush and ink, 7¾ x 7¾"

Pages 160 and 161
Front and back covers for *The Broken Spoke*. 1976. Pen and ink, watercolor, 6¾ x 17"

Pages 162 and 163
Based on the *Mystery!* television series, drawing for the edge of a note cube. 1988. Pen and ink, 3⅞ x 14⅛"

Pages 164 and 165
Poster (and detail) for *Mystery!* television series. Pen and ink (process color added), 24 x 16". Collection Gotham Book Mart, New York

Pages 166 and 167
Drawings for front and back covers of *Amphigorey Too*. 1975

Page 168
From *The Broken Spoke*. 1976. Pen and ink, watercolor, 3½ x 5½"

Page 169
Dedication page from *The Dong with the Luminous Nose*. 1969. Pen and ink, 3¾ x 6¾"

Page 170
From *Brer Rabbit and His Tricks* by Ennis Reese. 1967. Pen and ink, 6¼ x 7¾"

Page 171
From *QRV*. (Miniature). 1989. Fifteen images, pen and ink, each ⅝ x 1⅛"

Page 172
Cover design for *Phantasmagorey*. 1974. Pen and ink, 8¹¹⁄₁₆ x 5¾". Collection Clifford Ross

Page 177
Self-Portrait with Floating Cats. n.d. Pen and ink, watercolor, 7¼ x 5"

Page 188
Untitled. n.d. Pen and ink, watercolor, 10¼ x 5⅝" (sight). Collection Andreas Brown

Endpapers
Drawings for front and back covers of *Amphigorey Too*. 1975

Photograph Credits
The numbers below refer to page numbers.

102: Museum of Modern Art photo © 1996 Museum of Modern Art, New York; 148 and 149: Philip Beaurline; 179–185: Clifford Ross

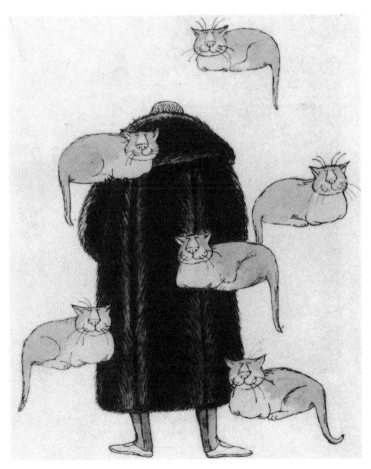

Self-Portrait with Floating Cats. n.d.

Chronology

Edward Gorey, a member of the class of 42, shown at the age of 15 during his sophmore year. Parker High School yearbook, Chicago, 1940

1925 Born, Chicago, Illinois

1928 Age three, teaches himself to read. Precocity continues; skips first and fifth grades.

1934 Reads *Rover Boys* books for the first time at summer camp. Forever impressed. Begins living with cats. (Continuous except for breaks when in the army and while attending Harvard.)

1943 Studies for one semester at the Chicago Art Institute.

1943–46 Serves in the U.S. Army as company clerk, Dugway Proving Ground, Utah, where mortars and poison gas were tested.

1946–50 Attends Harvard College. Rooms with Frank O'Hara. Reads Ronald Firbank, Evelyn Waugh, Ivy Compton-Burnett, Cecil Day-Lewis, Henry Green. Beginning of lifelong interest in French Surrealism, Symbolism, Chinese and Japanese literature. Graduates as a French major.

1953 Moves to New York; takes an apartment in 19th-century townhouse at 36 East 38th Street. Works for Doubleday Anchor Books art department until 1960; stays late at office to work on own books. First book, *The Unstrung Harp*, is published.

Meets Frances Steloff, founder of Gotham Book Mart. Miss Steloff becomes among the first to offer his books for sale.

1957 Begins attending performances of the New York City Ballet. Maintains record of perfect attendance until 1982. ("Balanchine did two or three new works per year. It's all one great glorious golden blur.")

1959 First important critical notice, by Edmund Wilson, in *The New Yorker*, December 26, 1959, for "The Albums of Edward Gorey."

1959–62 With Jason Epstein and Clelia Carroll, founds and works for Looking Glass Library, a division of Random House, which publishes classic children's books in hardcover; consulting editors are W. H. Auden, Phyllis McGinley, and Edmund Wilson.

1963 Works for Bobbs Merrill.

1965 Exhibition at California College of Arts and Crafts, Oakland.

1967 Andreas Brown buys Gotham Book Mart from Frances Steloff. Beginning of Gorey's expanded association with Gotham Book Mart as publisher, exhibitor, and archive for his art.

1968 Exhibition at Minnesota Institute of Arts, Minneapolis.

1970 First exhibition of works by Gorey in Gotham Book Mart Gallery; exhibits more or less annually since then. First publication of a Gorey book, *The Sopping Thursday*, by the Gotham Book Mart.

1971 Exhibition at University of Texas, Academic Center, Austin, and San Francisco Public Library, California.

1972 Publication of *Amphigorey*; chosen by *The New York Times* as one of the year's five noteworthy art books; wins American Institute of Graphic Arts award as one of the year's fifty best designed books. Max Ernst sees Gorey's exhibition at Gotham Book Mart Gallery, which includes drawings for *The West Wing*, and is extremely interested and enthusiastic.

1973 Exhibition at Pennsylvania State University, Pattee Library, University Park.

Designs sets and costumes for Nantucket summer theater production of *Dracula*, at behest of theatrical producer, writer, and director John Wulp. Later works with Wulp on numerous productions, including *Swan Lake*, *Giselle*, and *Le Bal de Madame H.*, for the Eglevsky Ballet.

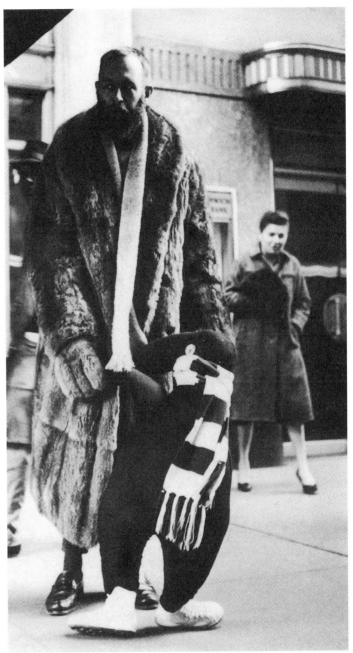

With the Doubtful Guest doll, New York City, 1958

1974 April–September: First major retrospective, *Phantasmagorey: The Work of Edward Gorey*, Sterling Memorial Library, Yale University, New Haven. Exhibition travels the U.S. for three years. Organized and catalogue written by Clifford Ross. ("Usually my work is exhibited as part of a cookie festival with tennis.") First of several exhibitions at Graham Gallery, New York.

1975 Makes only trip outside of the United States: to Fair Isle, the Orkneys, the Shetlands, the Outer Hebrides, and Loch Ness. ("I did not see the monster, to my great regret—the great disappointment of my life, probably.")

1977 Designs sets and costumes for *Dracula* on Broadway; wins Tony Award for costume design.

1978 January 27–February 5: *Gorey Stories,* a musical revue based on published works by Gorey, produced Off-Broadway, WPA Theatre; October 30, *Gorey Stories* opens on Broadway, Booth Theatre.

1980 Designs first version of animated titles for Public Broadcasting System's *Mystery!* in collaboration with Derek Lamb.

1981 Designs drop curtains for *The Concert,* ballet by Jerome Robbins.

1983 Designs sets and costumes for *The Mikado,* Carnegie-Mellon University Drama Department.

1985 Writes *Tinned Lettuce,* New York University. First musical revue written entirely by Gorey. Also designs sets and costumes.

1986 Designs sets and costumes for *Murder,* a David Gordon ballet. Premier danced by members of the American Ballet Theater at the War Memorial Opera House, San Francisco.

Opposite and pages 181–85:
Photos of Edward Gorey's Cape Cod home, 1994

Writes, directs, and designs sets and costumes for *Crazed Teacups* (Provincetown).

Profile, "Edward Gorey and the Tao of Nonesense," by Stephen Schiff, in *The New Yorker,* November 9.

1993 Writes, directs, and designs sets and costumes for *Chinese Gossip* and *Blithering Christmas* (Bourne, Mass).

1994 *Amphigorey* produced Off-Broadway.

1995 Writes, directs, and designs sets and costumes for *Inverted Commas* and *Stumbling Christmas* (Barnstable).

2000 Edward Gorey dies on April 15 at the age of 75.

Edward Gorey, 1994

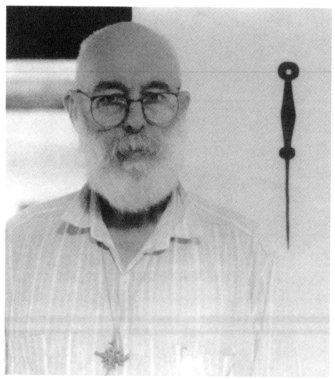

Leaves New York for Cape Cod, Massachusetts, first moving to Barnstable, and later settling in Yarmouthport. After departure, mummy's head found on closet shelf by building superintendent, who calls police. (In Yarmouthport, switches allegiance from New York City Ballet to Jack's Outback, a local eatery, where "all things considered," he has maintained an almost perfect attendance for breakfast and lunch.)

1987 *Lost Shoelaces*, a musical revue written by Gorey, produced in Woods Hole, Massachusetts. Also designs sets and costumes.

1990 Writes, directs, and designs sets and costumes for *Stuffed Elephants* (Woods Hole) and *Useful Urns* (Provincetown).

1991 Writes, directs, and designs sets and costumes for *Flapping Ankles* (Provincetown).

1992 Attends Albert York exhibition at Davis and Langdale Gallery; only visit to New York City since leaving in 1986.

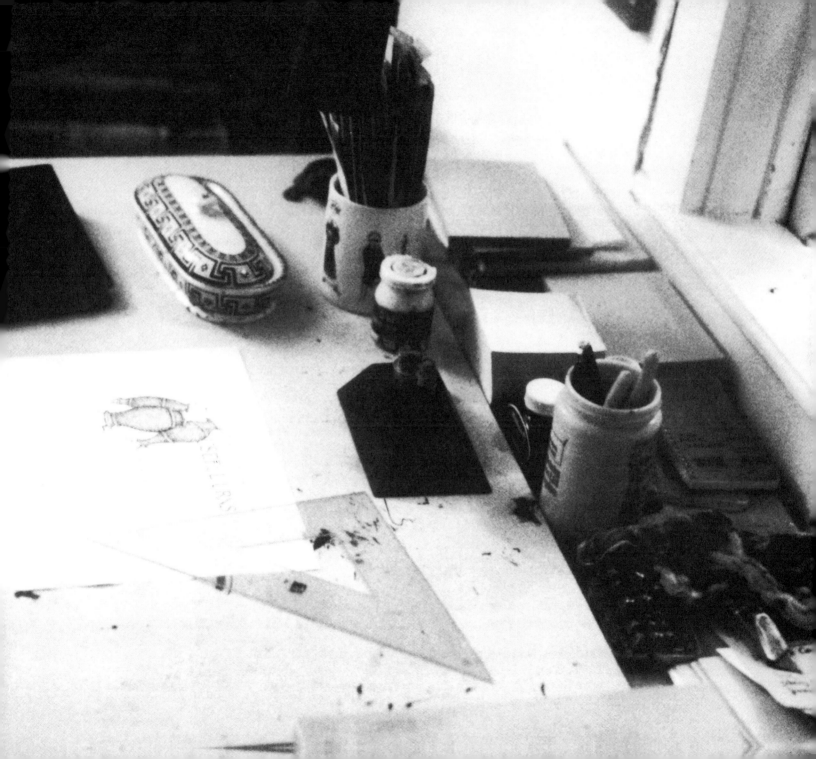

Bibliography

The following works are by Edward Gorey and are listed chronologically. Edward Gorey has adopted various anagrams of his name, including Regera Dowdy, Raddory Gewe, Aedwyrd Goré, D. Awdrey-Gore, Ogdred Weary, Garrod Weedy, and Dogear Wryde. Eduard Blutig and O. Müde are translations into German of "Edward Gorey" and "Ogdred Weary," respectively.

The Unstrung Harp. New York/Boston: Duell, Sloan & Pearce/ Little, Brown & Co., 1953.

The Listing Attic. New York/Boston: Duell, Sloan & Pearce/Little, Brown & Co., 1954.

The Doubtful Guest. Garden City: Doubleday & Co., 1957; London: Putnam & Co., 1958.

The Object Lesson. Garden City: Doubleday & Co.; London: Anthony Blond, 1958.

The Bug Book. Paperback. New York: Looking Glass Library, 1959. Hardcover reprint. New York: Epstein & Carroll, 1960.

The Fatal Lozenge: An Alphabet. New York: Ivan Obolensky, 1960.

—[Ogdred Weary, pseud.] *The Curious Sofa.* Paperback. New York: Ivan Obolensky, 1961. Hardcover reprint. New York: Dodd, Mead & Co., 1980.

The Gorey Alphabet. London: Constable, 1961.

The Hapless Child. Paperback. New York: Ivan Obolensky; London: Anthony Blond, 1961. Hardcover reprint. New York: Dodd, Mead & Co., 1980.

—[Ogdred Weary, pseud.] *The Beastly Baby.* Paperback. [New York:] The Fantod Press, 1962. Hardcover reprint. New York: Peter Weed; London: Purr, 1995.

The Willowdale Handcar or The Return of the Black Doll. Paperback. Indianapolis: Bobbs Merrill, 1962. Hardcover reprint. New York: Dodd, Mead & Co., 1979.

The Gashlycrumb Tinies or After the Outing. New York: Simon & Schuster, 1963.

The Insect God. New York: Simon & Schuster, 1963.

The Vinegar Works/Three Volumes of Moral Instruction. Boxed ed. of *The Gashlycrumb Tinies, The Insect God,* and *The West Wing.* New York: Simon & Schuster, 1963.

The West Wing. New York: Simon & Schuster, 1963.

The Wuggly Ump. Philadelphia: J. B. Lippincott Co., 1963.

[*The Nursery Frieze*]. [New York:] The Fantod Press, 1964.

The Sinking Spell. New York: Ivan Obolensky, 1964.

The Remembered Visit: A Story Taken From Life. New York: Simon & Schuster, 1965.

The Evil Garden, Eduard Blutig's Der Böse Garten in a Translation by Mrs. Regera Dowdy with the Original Pictures of O. Müde. New York: The Fantod Press, 1966.

The Inanimate Tragedy. [New York:] The Fantod Press, 1966.

—[Mrs. Regera Dowdy, pseud.] *The Pious Infant.* New York: The Fantod Press, 1966.

3 Books From The Fantod Press [I]. Ed. of *The Evil Garden, The Inanimate Tragedy,* and *The Pious Infant.* New York: The Fantod Press, 1966.

The Gilded Bat. New York: Simon & Schuster, 1966; London: Jonathan Cape, 1967.

The Utter Zoo. New York: Meredith Press, 1967.

Gorey, Edward, and Victoria Chess. *Fletcher and Zenobia.* New York: Meredith Press, 1967.

The Blue Aspic. New York: Meredith Press, 1968.

The Secrets: Volume One, The Other Statue. New York: Simon & Schuster, 1968.

The Epilectic Bicycle. New York: Dodd, Mead & Co., 1969.

The Iron Tonic: or A Winter Afternoon in Lonely Valley. New York:

Albondocani Press, 1969.

The Chinese Obelisks: Fourth Alphabet. New York: The Fantod Press, 1970.

The Osbick Bird. [New York:] The Fantod Press, 1970.

The Sopping Thursday. New York: Gotham Book Mart and Gallery, 1970.

Three Books from the Fantod Press [II]. Ed. of *The Chinese Obelisks, Donald Has a Difficulty,* and *The Osbick Bird.* [New York:] The Fantod Press, 1970.

Gorey, Edward, and Peter F. Neumeyer. *Donald Has a Difficulty.* [New York:] The Fantod Press, 1970.

—. *Why We Have Day and Night.* New York: Young Scott Books, 1970.

The Deranged Cousins or, Whatever. [New York:]The Fantod Press, 1971.

The Disrespectful Summons. [New York:] The Fantod Press, 1971.

—[Raddory Gewe, pseud.] *The Eleventh Episode.* Drawings by Om. [New York:] The Fantod Press, 1971.

Fletcher and Zenobia Save the Circus. Illustrated by Victoria Chess. New York: Dodd, Mead & Co., 1971.

Three Books from the Fantod Press [III]. Ed. of *The Deranged Cousins, The Eleventh Episode,* and *[The Untitled Book].* [New York:] The Fantod Press, 1971.

—[Edward Pig, pseud.] *[The Untitled Book].* [New York:] The Fantod Press, 1971.

Gorey, Edward, trans. *Story for Sara, What Happened to a Little Girl* by Alphonse Allais. Drawings by Edward Gorey. New York: Albondocani Press, 1971.

The Abandoned Sock. [New York:] The Fantod Press, 1972.

Amphigorey. New York: G. P. Putnam's Sons, 1972.

The Awdrey-Gore Legacy. New York: Dodd, Mead & Co., 1972.

Leaves from a Mislaid Album. New York: Gotham Book Mart, 1972.

The Black Doll, a Silent Film. New York: Gotham Book Mart, 1973.

Categorey, Fifty Drawings. New York: Gotham Book Mart, 1973.

Fantod IV, Three Books from the Fantod Press. Ed. of *The Abandoned Sock, The Disrespectful Summons,* and *The Lost Lions.* [New York:] The Fantod Press, 1973.

The Lavender Leotard: or, Going a Lot to the New York City Ballet. New York: Gotham Book Mart, 1973.

A Limerick. Dennis, Mass.: Salt-Works Press, 1973.

The Lost Lions. [New York:] The Fantod Press, 1973.

The Listing Attic and The Unstrung Harp. London: Abelard, 1974.

Amphigorey, Too. New York: G. P. Putnam's Sons, 1975.

The Glorious Nosebleed, Fifth Alphabet. New York: Dodd, Mead & Co., 1975.

L'Heure Bleu. [New York:] The Fantod Press, 1975.

Les Passementeries Horribles. New York: Albondocani Press, 1976.

The Broken Spoke. New York: Dodd, Mead & Co., 1976; London: Ernest Benn, 1979.

Dogear Wryde Postcards: Scènes de Ballet Series. Designed for the New York City Ballet. N.p. 1976.

The Loathsome Couple. New York: Dodd, Mead & Co., 1977.

Dogear Wryde Postcards: Alms for Oblivion Series. N.p. 1978.

The Green Beads. New York: Albondocani Press, 1978.

Dogear Wryde Postcards: Interpretive Series. N.p. 1979.

Dracula: A Toy Theater. New York: Charles Scribner's Sons, 1979.

Gorey Posters. New York: Harry N. Abrams, Inc., 1979.

Dancing Cats and Neglected Murderesses. New York: Workman Publishing; London: J. M. Dent & Sons, 1980.

Dogear Wryde Postcards: Neglected Murderesses Series. N.p. 1980.

F.M.R.A. New York: Andrew Alpern, 1980.

Les Urnes Utiles. Cambridge, Mass.: Halty-Ferguson Publishing Co., 1980.

Le Mélange Funeste. New York: Gotham Book Mart, 1981.

The Dwindling Party. New York: Random House; London: Heinemann, 1982.

The Water Flowers. New York: Congdon & Weed, 1982.

Amphigorey Also. New York: Congdon & Weed, 1983.

The Eclectic Abecedarium. Boston: Anne & David Bromer, 1983.

E. D. Ward: A Mercurial Bear. New York: Gotham Book Mart, 1983.

The Prune People. New York: Albondocani Press, 1983.

The Tunnel Calamity. New York: G. P. Putnam's Sons, 1984.

Les Echanges Malandreux. Worcester, Mass.: Metacom Press, 1985.

The Prune People II. New York: Albondocani Press, 1985.

The Improvable Landscape. New York: A Piermont Book/Albondocani Press, 1986.

The Raging Tide: or, The Black Doll's Imbroglio. New York: A Peter Weed Book/Beaufort Book Publishers, 1987.

Dogear Wryde Postcards: Menaced Objects Series. N.p. 1989.

Dogear Wryde Postcards: Tragédies Topiares Series. N.p. 1989.

The Dripping Faucet/Fourteen Hundred & Fifty Eight Tiny, Tedious, & Terrible Tales. Worcester, Mass.: Metacom Press, 1989.

The Helpless Doorknob/A Shuffled Story. N.p. 1989.

Q.R.V., Boston: Anne and David Bromer, 1989. Reissued as *The Universal Solvent*. [Cape Cod:] The Fantod Press, 1990.

Dogear Wryde Postcards: Whatever Next? Series. N.p. 1990.

The Fraught Settee. [Cape Cod:] The Fantod Press, 1990.

—[Eduard Blutig, pseud.] *The Stupid Joke*. Translation by Mrs. Regera Dowdy with original pictures by O. Müde. [Cape Cod:] The Fantod Press, 1990.

—[Eduard Blutig, pseud.] *The Tuning Fork*. Translation by Mrs. Regera Dowdy with original pictures by O. Müde. [Cape Cod:] The Fantod Press, 1990.

La Ballade Troublante. [Cape Cod:] The Fantod Press, 1991.

The Betrayed Confidence/Seven Series of Dogear Wryde Postcards. Orleans, Mass.: Parnassus Imprints, 1992.

Two Novels: The Grand Passion [and] The Doleful Domesticity. [Cape Cod:] The Fantod Press, 1992.

—[Dogear Wryde, pseud.] *The Floating Elephant* [and] [Ogdred Weary, pseud.] *The Dancing Rock*. 2 vols. in 1, bound back to back. N.p. 1993.

—[Garrod Weedy, pseud.] *The Pointless Book: or, Nature & Art*. In Two Volumes Bound Together. [Cape Cod:] The Fantod Press, 1993.

—[Aedwyrd Goré, pseud.] *Figbash Acrobate*. N.p. 1994.

The Retrieved Locket. [Cape Cod:] The Fantod Press, 1994.

The Fantod Pack. New York: Gotham Book Mart, 1995.

The Unknown Vegetable. [Cape Cod:] The Fantod Press, 1995.

Selected Collaborations, with Edward Gorey listed as illustrator. Entries are listed chronologically.

Ciardi, John. *The Man Who Sang the Sillies*. Philadelphia: J. B. Lippincott Co., 1961.

—. *You Read to Me, I'll Read to You*. Philadelphia: J. B. Lippincott Co., 1962.

—. *You Know Who*. Philadelphia: J. B. Lippincott Co., 1964.

Untitled. n.d.

Saki. *Die Offene Tür* (The complete short stories). Zurich: Diogenes Verlag, 1964.

Ciardi, John. *The King Who Saved Himself from Being Saved.* Philadelphia: J. B. Lippincott Co., 1965.

—. *The Monster Den or Look What Happened at My House—and To It.* Philadelphia: J. B. Lippincott Co., 1966.

Rees, Ennis. *Brer Rabbit and His Tricks.* New York: Young Scott Books, 1967.

—. *More of Brer Rabbit and His Tricks.* New York: Young Scott Books, 1968.

Spark, Muriel. *The Very Fine Clock.* New York: Alfred A. Knopf, 1968.

Lear, Edward. *The Jumblies.* New York: Young Scott Books, 1968.

—. *The Dong with the Luminous Nose.* New York: Young Scott Books, 1969.

Ciardi, John. *Someone Could Win a Polar Bear.* Philadelphia: J. B. Lippincott Co., 1970.

Moss, Howard. *Instant Lives.* New York: Saturday Review Press/E. P. Dutton, 1974.

Wilson, Edmund. *The Rats of Rutland Grange.* New York: Gotham Book Mart, 1974.

Beckett, Samuel. *All Strange Away.* New York: Gotham Book Mart, 1976.

Eliot, T. S. *Old Possum's Book of Practical Cats.* New York: Harcourt Brace Jovanovich Publishers, 1982.

Saki. *Saki's Stories.* Selected and with an introduction by Graham Greene. Franklin Center, PA: The Franklin Library, 1982.

Woolf, Virginia. *Freshwater, A Comedy.* San Diego: Harcourt Brace Jovanovich Publishers, 1985.

Beckett, Samuel. *Beginning to End.* New York: Gotham Book Mart, 1988.

Updike, John. *The Twelve Terrors of Christmas.* New York: Gotham Book Mart, 1993.

Back cover design for *The Gashlycrumb Tinies or, After the Outing.* 1963

From *Figbash Acrobate* (a Figbash alphabet). 1994

Where will it all end?